ACRYLIC TECHNIQUES

Lionel Aggett

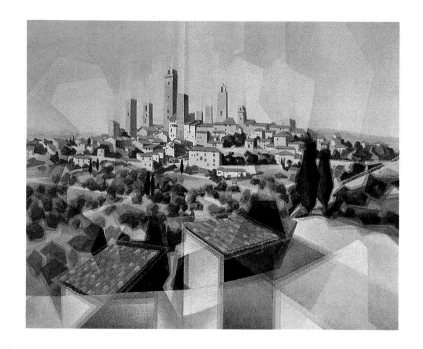

The Crowood Press

CONTENTS

Contents

INTRODUCTION

Acrylic paint was first produced in Mexico in the 1930s; since then it has developed into one of the most versatile media available. There are many ways of applying the paint, and most, if not all, are included in this book. I have not, for instance, described how to throw acrylic at the canvas, nor have I demonstrated how to use the paint direct from the tube. Both methods are acknowledged as acceptable practices, however, and I hope the techniques illustrated in this book will encourage you to experiment and come up with your own ideas. The possibilities are almost endless.

Scope

There is something here for everyone. Whether you are just starting out, or are an experienced painter who has not tried this medium before, I hope that in this book you will find the inspiration to take acrylic paint, practise, experiment, and then push its capability to the limit and beyond. The more established acrylic painters among you may wish simply to compare notes: there may be an avenue you might think worth exploring, or a spark to kindle an approach which has, until now lain dormant.

For those of you who are starting, I have described the essential materials required to set you on your way. Further materials are introduced later. Supports, paints, colour and tone are discussed before the basic techniques of applying the acrylic paint are demonstrated. Later on in the book I describe eight approaches to acrylic painting. Each technique is introduced with demonstrations and an example of a completed painting, followed by a four-stage demonstration, using the same subject for direct comparison.

I have concentrated on the application techniques of acrylic paint rather than subject techniques, such as how to paint trees, figures, water, sky and so on. These do appear where relevant, but under the umbrella of the application technique.

The range of colours available is explained and suggestions are made with regard to choice and palette. I describe my personal palette, and details of the colours chosen for each demonstration are given with mixing illustrations shown on the left-hand side of the support used for the painting. Details of the support used are also given in each case.

Subject Matter

I have painted the illustrations specifically for this book, with the exception of seven paintings that were completed earlier. Apart from visits to France and Germany, most of the subjects are located in my native Devon, Cornwall and the Isles of Scilly; many are located near to the studio. You do not have to travel far to find a subject, even less should you decide to paint a still life! Many inexperienced painters drive around and around trying to find the perfect view. With our Devon hedges this can often be tiresome! Keep the subject matter fairly simple at first. A field, tree and cloud can make an interesting composition. If you cannot for whatever reason, get out and about, look at the garden, yard, patio or even out of the window. Above all, do try to paint direct from life.

Follow Procedure

If you are inexperienced, do not feel tempted to start on the exercises before you have read through the book.

You will, I hope, be feeling stimulate towards making a start, but resist th temptation until you have graspe the overall picture. Then come bac to the beginning and work throug the exercises, adapting and choosin your own subjects as you wish. Rela and enjoy yourself. Explore the poter tial of acrylics by experimenting be ween practice sessions and exercise: You will soon find that the mediur is, quite literally, extremely plastic: will bend and allow you to stam your authority on it, and it will readi assist in the development of your ow expression, once you have mastere the basic techniques.

Summary

■ Acrylic paint is one of the most versatile media available today.
■ This book deals specifically with the application of the medium to a variety of supports.
■ There is something within the following pages for both the inexperienced and more accomplished painter.
■ Nearly all the paintings have been painted especially for this book.
■ Palettes and mixing details are given for each demonstration.
■ Work through the book, following the procedures as indicated. Resist the temptation of jumping to the last section to try the more advanced techniques before tackling the basics – particularly if you are starting out.
■ Once you have mastered the basic techniques, the book should also help you to develop your own expression through experimentation and extension of the various approaches illustrated.

Example: M5 Earthworks, Sandygate, Exeter

This small painting, completed in 1974 as one of a series during the construction of the M5 at Exeter, shows acrylic paint handled in a loose-brush manner embodying some of the basic techniques described in this book: impasto, scumbling, wet in wet, and glazing have all been used to portray the vibrant Devon red earth laid bare like an open wound running through the countryside.

The treatment is simple, uncluttered and direct and indicates the level of competence you should achieve, with practice, after reading the book and working through the exercises. It is convenient sometimes to work from photographs, but there is really no substitute for working direct from nature. You will be forced to OBSERVE and learn through experience, which of course means making mistakes. Don't worry, we all do!

MATERIALS
For Example

- Smooth face of hardboard, natural colour, sealed with acrylic medium.
- Brushes: Short flat hog Nos 4 and 8; long filbert hog No. 4; synthetic flat No. 4, 8.
- Paint: Ultramarine Blue, Burnt Sienna, Venetian Red, Crimson, Cadmium Red, Yellow Ochre, Permanent Yellow, Titanium White.

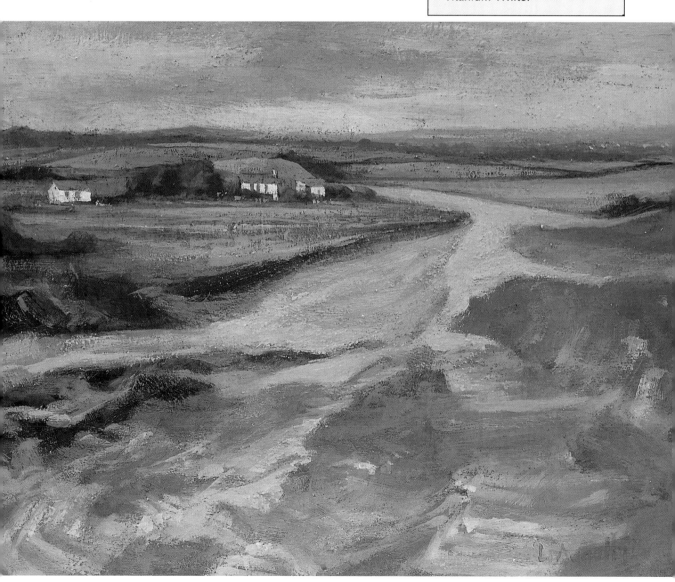

THE ACRYLIC MEDIUM

The Mexicans' desire in the 1920s to paint large external murals which would withstand climatic conditions led to commercial laboratory research which resulted in the development of the two synthetic resins, acrylic and polyvinyl acetate (PVA). These polymerized media are used to bind the pigments. The term polymer means the combining of small identical molecules to form a larger molecule.

Acrylic polymer resins (made from acrylic and metacrylic acids) are mixed with suitable additions to form a medium that is soluble in water. This medium is a milky-white emulsion which will dry as a transparent film when the water has evaporated. Pigments bound in the acrylic medium can be thinned with water or other medium, or, if you wish, with a mixture of both.

When the water has evaporated and the acrylic paint has dried, there is no further chemical reaction. This property opened up all sorts of possibilities, the greatest advantage being that successive coats can be applied quickly, and without fear of the layers breaking down. The chemical structure produces a porosity which allows the water to evaporate from all layers.

The paint is adhesive, tough, and flexible and is resistant to oxidizing and chemical decomposition, just what the Mexicans were seeking. It is opaque, but can be thinned to any degree of transparency.

Acrylic and PVA

Paints made from acrylic resin as described above are permanent, reliable and are not prone to yellowing. Internationally known manufacturers such as Rowney, Winsor and Newton, Liquitex, and Maimeri produce acrylic paints of fine artist's quality.

Paints made from PVA (polyvinyl acetate) although cheaper, do not perform so well. More importantly they lack permanence, and are subject to yellowing. I know this from first-hand experience. I completed a large canvas in the mid-sixties, and used PVA medium as a final glaze. It is one work that I kept, thank goodness, for the yellowing has killed the painting.

Ancillary Items

A range of mediums, extenders, texture pastes and retarders help to provide a system that is the most versatile available. These are fully covered in the following pages.

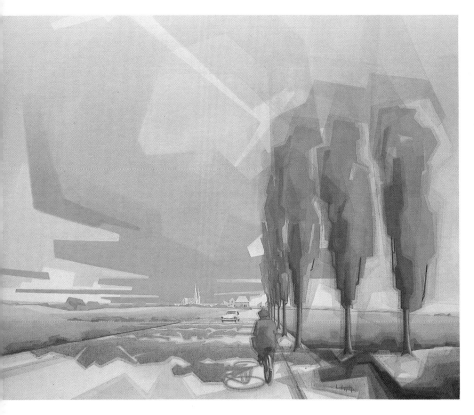

L'homme et sa bicyclette, Chartres, France *The three paintings illustrated on these two pages are painted in my studio technique, which I am constantly developing in parallel with en plein air work. I also use watercolour, oils, pastel and charcoal during the course of the development, but I sense that I will ultimately break through with the acrylic medium.*

Opaque passages, scumbling, and glazing are used extensively, capitalizing on the quick-drying property of acrylic paint. Chârtres Cathedral appears to be growing out of the fields surrounding the city, against the threatening sky, with the general mass hidden from view. The car and opposing man on a bicycle, coupled with deep perspective, heighten the drama.

Feeding the Land, Launceston, Cornwall *This painting further illustrates the medium's capacity in the use of scumbling and glazes. Modern farming machinery serving the land that has been worked for centuries, is related to the historic mound and castle keep in a symbolic manner, using opaque passages and glazes. The scattered fertilizer has been painted using the scumbling method.*

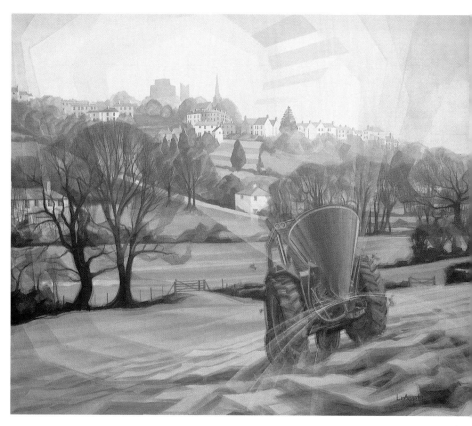

Summary

- Acrylic paint was first developed in South America.
- Artist's acrylic paint is permanent and reliable.
- PVA paint is cheaper but unreliable.
- Acrylic paint can be used in opaque or translucent form.
- It is quick-drying, waterproof, and can be rapidly built up in layers.
- Adhesive, tough and flexible, it can be applied to almost anything, but being water-suspended, it will not take over oil-based grounds or oil paint.
- Mediums, extenders, texture pastes and retarders combine to provide a system of immense versatility.

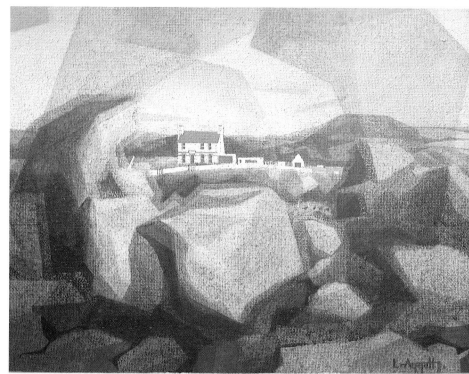

Old Town Bay, Isles of Scilly *This painting shows the paint applied thickly and then thinly in glazes. The foreground granite boulders were painted fairly thickly in opaque paint, dark and light, before glazes were applied to produce further tone and shadow. Forms were extended upwards with glazes to accentuate the point of interest, the cottage.*

MATERIALS AND EQUIPMENT

The materials illustrated on these two pages will be sufficient to get you started if the medium is new to you. You do not need to buy everything shown here, as indicated in the notes, but the general selection should cover your needs for the first part of the book. I shall be introducing you to further materials to enable you to tackle the more advanced techniques as we proceed.

Individual Items and Boxed Sets

I have presented items individually so that you can, if you wish, proceed gradually with your purchases. Paints, brushes and mediums can, of course, be obtained in complete boxed sets and I will leave you to investigate, according to your purse, the stock at your local art dealer.

If you already paint using other media or are an established acrylic painter, then you will most probably possess an easel. If, on the other hand, you are just starting out, an easel, although preferable, is not absolutely essential right away. A simple home-made table easel will suffice, or anything that can be used to prop up the board or canvas such as a wood block or books.

Paint *The following six tubes of Cryla Standard Formula paint will be sufficient for the first few exercises: Ultramarine Blue, Burnt Sienna, Crimson, Yellow Ochre, Permanent Yellow, Titanium White.*

Brushes *I have shown brush types that are useful. You will see I have included hog brushes, but nylon is cheaper and will do. I prefer the feel and spring of hog. From left to right: synthetic round No. 20; sable rigger No. 4; hog short flats Nos 12, 8, 4; long filberts Nos 8, 4; synthetic flats Nos 14, 8.*

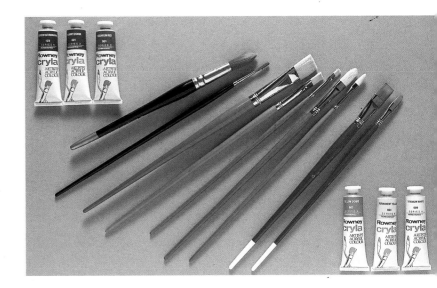

Gesso primer *This is for use when preparing your own supports and grounds. Highly adhesive, ideal for sealing absorbent surfaces. Dries quickly and creates a matt white surface with a slight tooth.*

Acrylic matt medium *Can be mixed with acrylic paint to thin down, and produce transparent glazes. Milky white, but colourless when dry.*

Bucket, pots and water *Use a bucket to clean brushes, and use pots for thinning. Brushes must be cleaned in water immediately after use and kept in the water compartment of your staywet palette (or tray) during painting.*

Materials and Equipment

Choice of Materials

I have already mentioned PVA, which is a cheaper alternative to artist's acrylic paint. This is fine for practice, but it does not possess the finer qualities of the latter and I would recommend that you start with and get used to acrylics. I have used the internationally known Rowney Cryla, both Standard and Flow Formulas throughout this book. The American Liquitex and Italian Maimeri acrylics are also very good, and all produce mediums and ancillary items. I would advise you to have a look at what is available and perhaps buy individually to try out the various manufacturers' items.

Checklist of Materials

- Six tubes of acrylic paint as suggested.
- Assortment of, say, six brushes from the selection: synthetic round No. 20, sable rigger No. 4, hog or synthetic short flats Nos 12, 8, 4, and hog or synthetic filbert No. 4.
- Gesso Primer.
- Assortment of news-paper, brown paper, old magazines, card, hardboard, plywood, linen, hessian, and canvas board. Canvases can come later.
- Acrylic matt medium.
- Bucket, and pots, such as jam jars, and of course clean water.
- Pencils, HB and 2B, charcoal, and palette knife.
- Staywet palette or plastic palette. Paint will have to be kept moist if you use the latter.
- Easel and composite or compressed fibre board.
- Eraser.

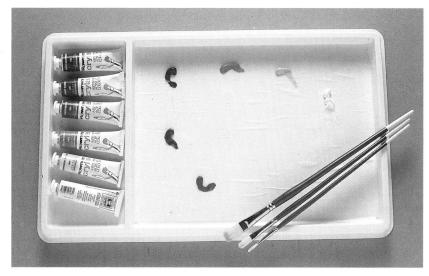

Staywet Palette *Acrylic paints will dry very quickly on a conventional palette. The staywet palette will keep paint moist for weeks. Moisture evaporating from the surface is replaced by water from the dampened reservoir paper beneath the semi-permeable membrane which forms the working surface of the palette. The tray has a lid. Note the water compartment to the left for keeping brushes wet. It can, as illustrated, also be used to transport six tubes comfortably. I have also shown three less expensive hog brushes, left to right: long flat No. 8, filberts Nos 4 and 2. Note the palette arrangement.*

Pencils, charcoal and palette knife *Pencils HB, and 2B, or charcoal can be used for setting out. The palette knife is normally used for mixing but can also be used for painting.*

Easels and boards *An easel is preferable but not essential at this stage. Other adequate means of support will do, wood blocks or even books, to rest your canvas or board. I use the large radial easel in the studio. The box easel, second from left, is handy for carrying paints and brushes, but could be rather heavy over long distances. The table easel is ideal for indoor work but obviously not of much use on location. The standard beechwood easel, far right, is most reliable and useful. It has stood up well for me over the past thirty-two years; an early investment, it is still going strong. Any easel you choose needs to be rigid, so test them out in the shop.*

SUPPORTS AND GROUNDS

It is the unique qualities of acrylic paint, its strong adhesive power, toughness, flexibility and durability, that enable the medium to be applied to a wide variety of surfaces. The paint can be applied to almost any absorbent support without first applying an undercoat or primer. However, it is more usual to apply a primer to ease the flow of paint and control the tint of the ground.

Primers

Having said that acrylics are compatible with most surfaces, there are two important exceptions: emulsion and oil paint. Ordinary emulsion paints must be avoided as a cheap ground, for although they are water-based they may not be chemically compatible with acrylics. Oil paint must be avoided because the synthetic resin which is water-suspended will simply not take on an oil-based ground. If you do decide to use an undercoat, an acrylic gesso primer must be used.

Types of Support

Canvas or canvas board are the most commonly used supports for final works and these are dealt with on the next two pages. There are other extremely popular surfaces which are used for professional works, and some that are ideal for practising basic techniques and, particularly at this early stage, for developing a feel for the medium.

For experimenting with colours, and mixing and trying out various brushes, ordinary newspaper will do. All of the surfaces illustrated or mentioned here can be used plain or treated with a thin coat of gesso. Brown paper is ideal and can be mounted on card if you wish. Cardboard of all types is good. Visit your local hardware shop and ask for delivery boxes, which can then be cut into panels. Watercolour paper is fine and needs no priming. Wood is a very good support either in natural form, as blockboard or plywood, or hardboard strengthened with battens at the back.

Brown paper mounted on card
Venetian Red applied thinly over gesso primer and plain card followed by thick layer. Paper produces pleasant texture where paint is thin.

Brown packaging card *This is quite rigid because of the corrugated core, and is useful for practice and experimental work.*

Grey mounting card *Quite useful for practice and getting used to the behaviour of colours and their relationships when mixed. Apply some paint thickly. When dry, bend card to see how flexible the paint is.*

Old magazines These can be very useful for sketching, particularly if you are just starting and for some reason can not get out and about. They not only provide an inexpensive book, but you can use one side of a two-page spread as a painting surface, primed with gesso, and refer to the illustration on the opposite page as a model! The finished sketches will not crack either, as the paint is so flexible. Use magazines with a fairly stout paper.

Newspaper Use the paint fairly thickly otherwise the paper will return to pulp. Primer will seal and strengthen the paper. The most convenient surface for playing with, sketching and getting used to acrylic paint.

Plywood This can be used for fairly large work where, like hardboard, some support in the form of battening is required at the back to prevent warping.

All types of wood panel can produce interesting textures as can be seen here where the Crimson paint has been thinly applied, both over the gesso ground and plain plywood.

Hardboard This is very popular although, like all materials, it is not so cheap as it used to be. Nevertheless small panels need no strengthening and are suitable for serious work. Some artists use the porous rear machine-textured surface. I find this to be almost too regular and prefer to paint on the smooth finished face.

Watercolour paper Watercolour paper (in this instance Saunders Waterford Not, 638gsm), is very good to work on. There is no need to use a primer, although for the purpose of comparative analysis I have applied a coat of acrylic gesso to the right-hand side of the paper. Notice the effect this has on the two applications of Ultramarine paint. The paint can be applied thickly (impasto) or thinly as one would use watercolour. Remember that when dry, the paint is waterproof. Alterations can only be made by painting over using the opaque properties of the paint.

Supports and Grounds

I have used the three primary colours to express the textural qualities of the surfaces illustrated on these two pages.

A thinly applied ground of Burnt Sienna plus Ultramarine has been painted over part of the primed surface. The colours have been mixed with water tension breaker to produce a uniform surface. In each instance, two primaries have been shown in vertical banks, and mixed to provide the secondary colour painted horizontally and with the remaining complementary primary painted above. The two remaining secondaries are produced through the glazed overpainting with complementaries shown opposite.

Material applied to card *Old sheets, shirts or anything capable of producing a reasonable texture can be used. Apply to card with acrylic paste or glaze medium, and then coat with acrylic gesso primer. Primary colours red and blue; secondary colour, violet; complementary primary colour, yellow.*

Canvas panels *Primary colours, blue and yellow; secondary colour, green; complementary primary colour, red. Ready-prepared and primed canvas-covered panel with turned edges and backing. These are produced by the leading manufacturers and are usually fine-grained. They are ideal for both sketching and finished works, and are available in a variety of sizes from 254 × 175mm (10 × 7in) to 762 × 508mm (30 × 20in).*

Hessian panel *Primary colours, yellow and red; secondary colour, orange; complementary primary colour, blue. Raw hessian applied to a hardboard or plywood panel with acrylic paste or glaze medium. The surface can be left raw, or primed with acrylic gesso primer.*

Hessian provides a lively woven texture which becomes very pronounced when coated with a thin application of paint using water tension breaker. These panels can be made up to any size, but strengthen with battens for larger paintings, for example 610 × 457mm (24 × 18in).

Jute canvas *Primary colours, blue and red; secondary colour, violet; complementary primary colour, yellow. Jute is a strong coarse grain and is ideal for landscapes and large-scale work. The canvases are usually double-primed with acrylic gesso. Sizes range from 305 × 254mm (12 × 10in) to 914 × 711mm (36 × 27½in). Canvas is also available in 5m rolls, 1067mm (41½in) and 2134mm (83in) wide. You can buy stretcher pieces to make up your own canvases.*

Cotton Canvas . *Primary colours, yellow and blue; secondary colour, green; complementary primary colour, red. These made-up canvases are usually medium grain, and are double-primed with acrylic gesso. They are good for general work. Sizes range from 305 × 254mm (12 × 10in) to 1524 × 1016mm (59½ × 39⅓in).*

Flax canvas *Primary colours, red and yellow; secondary colour, orange; complementary primary colour, blue. This material has a fine-grain surface and is particularly good for detailed work. It is also suitable for many styles of landscape, marine painting and portraiture. The pure flax is usually double-primed with acrylic gesso. Sizes range from 305 × 254mm (12 × 10in) to 1219 × 914mm (48 × 36in).*

COLOUR, PALETTE, AND MIXING

The range of colours produced by all manufacturers of the acrylic medium are very extensive. All the traditional colours are available as well as an impressive range of new synthetic pigments. Laboratory research has resulted in the production of chemical formulas that are totally new. Phthalocyanine Blue, Turquoise Green and Indanthrene Blue are such examples.

Choosing the Paint

All colours are available in both Cryla and Cryla Flow Formulas, with the exception of Burnt Sienna which is available in Cryla only. I generally

Blue and yellow makes green
I prefer to mix my own greens as many standard greens are too strong. A personal view only. The illustration shows a mix of Ultramarine Blue and Permanent Yellow, further lightened with white.

prefer Cryla, which has a smooth, buttery type of consistency that retains the intended stroke of brush or knife. It can be thinned with water and/or an acrylic medium. Cryla Flow has a more fluid formulation, ideal for underpainting, covering areas of flat colour and for hard-edge techniques.

You do not need a large palette, and twelve to fifteen colours chosen carefully from the range is the maximum required. These may change

over the years as your personal approach develops.

Illustrated on these two pages are some basic mixes.

Typical Range

The full range of Rowney colours are:

1A Primrose	1B Lemon Yellow	1C Cadmium Yellow Pale
2A Permanent Yellow	2B Cadmium Yellow	2C Cadmium Yellow Deep
3A Cadmium Orange	3B Rowney Orange	3C Cadmium Scarlet
4A Vermilion Hue	4B Cadmium Red	4C Permanent Rose
5A Cadmium Red Deep	5B Crimson	5C Red Violet
6A Permanent Violet	6B Deep Violet	6C Indanthrene Blue
7A Monestial Blue (Phthalocyanine)	7B Coeruleum	7C Cobalt Blue
8A Ultramarine	8B Rowney Turquoise	8C Monestial Turquoise (Phthalocyanine)
9A Hookers Green	9B Monestial Green (Phthalocyanine)	9C Rowney Emerald
10A Opaque Oxide of Chromium	10B Pale Olive Green	10C Bright Green
11A Yellow Ochre	11B Golden Ochre	11C Bronze Yellow
12A Raw Sienna	12B Burnt Sienna	12C Flesh Tint
13A Venetian Red	13B Transparent Brown	13C Burnt Umber
14A Raw Umber	14B Payne's Grey	14C Ivory Black
15A Mars Black	15B Middle Grey	15C Titanium White

Cadmium Red. Permanent Yellow

White

Orange

Cadmium Red Cobalt Blue

White

Violet

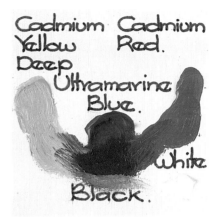

Cadmium Cadmium Yellow Red. Deep Ultramarine Blue.

White

Black.

Red and yellow makes orange
Cadmium Red and Permanent Yellow mixed to produce a bright orange further lightened with Titanium White. The orange will move towards red or yellow according to the amount of that colour applied.

Red and blue makes violet
Cadmium Red and Cobalt Blue mixed to produce a violet, lightened with Titanium White. Red violets and blue violets can be mixed according to the proportions used.

Yellow and red plus blue makes black *I do not include black in my palette as I believe there is always a colour accent present, and I feel black from the tube is too dense. Here, I have mixed Cadmium Yellow Deep, Cadmium Red and Ultramarine Blue.*

Summary

■ Do not be tempted to have too many colours in your palette. Work with six to eight chosen from between twelve and fifteen.
■ Place colours on the palette in an ordered manner, and keep to the same layout (you will eventually do this without thinking, and it will speed up your painting process).
■ Choose a good balance of colours.
■ Decide whether to use black (you can mix it).
■ Incorporate a green if you wish but use it sparingly if you do. Do not overdo the mixing or your colours will become muddy. Add blue to cool down colours; add red to make them warmer.

Palette *My maximum palette is fourteen colours: Permanent Yellow, Cadmium Yellow Deep, Yellow Ochre, Raw Sienna, Cadmium Red, Crimson, Burnt Sienna, Venetian Red, Burnt Umber, Raw Umber, Monestial Blue, Ultramarine Blue, Cobalt Blue and Titanium White.*

I hardly ever use this many, and usually no more than eight are dispensed on my staywet palette. I have used these colours throughout the book and you can do the same if you wish, or use them as a basis for your own selection. Make sure you achieve a good balance of colours bearing in mind that there are no greens in mine.

I have produced five different mixes in green, three for orange, three for grey and six for violet, to give an indication of the scope there is for providing subtle variations. Raw Sienna and Raw Umber are yellows, and when mixed with Ultramarine and Monestial Blue respectively, landscape greens of tremendous depth are achieved. Raw Sienna and Cadmium Red produce a dull orange, whereas the orange made by mixing Permanent Yellow and Cadmium Red is bright. Ultramarine and Venetian Red make a useful grey/violet.

Too many colours will produce a muddy mix. Blues, generally, are cool and reds are warm. Change the temperature by adding as appropriate.

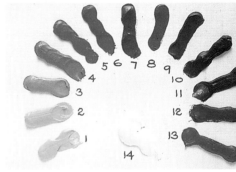

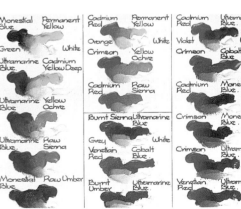

TONE

Whether you are painting in acrylics, oils, pastels, watercolour, gouache, or making a drawing, it is essential to understand what is meant by tone. All subject matter comprises many tonal values, and the correct representation of these values is as important, if not more so, than the appreciation of colour, which we can readily see and identify.

Summary

■ Tonal value refers to the degree of lightness and darkness of objects in a subject. All other degrees of tone will fall between these two extremes.
■ When painting, locate the darkest dark and the lightest light, and then decide at which point between these extremes a particular object falls. If using a camera, shoot black and white film and take colour notes with sketches.
■ Paint on site as often and whenever you can.
■ Squint your eyes when assessing tonal value.
■ Aim for tonal harmony in your painting.

What is meant by Tonal Value?

The tonal value of objects in a painting is their degree of lightness and darkness. There will be an area that is lightest and one that is darkest. All other tonal values in the subject will fall between these two extremes. A black and white photograph will illustrate this very well. If you study an example in a newspaper, say, you will soon be able to locate the darkest dark and the lightest light. The many tonal values in between these extremes can then be analysed.

Evaluating Tonal Value

The tonal variations in a picture help to establish form, distance, texture, light and shade. When painting or drawing on the spot, locate the darkest dark and lightest light. It is helpful to record these early on in your painting. You can then decide at which point between these extremes a particular object or area of the subject falls. It will help if you squint your eyes as you look. This will act as a filter and render the tonal contrasts easier to assess. Aim for tonal harmony, that is a good balance between light and dark. If, through lack of time you are recording material with a camera, it makes sense to use black and white film. The tonal values will be captured and together with colour and sketch notes you will have the basis for a picture.

The examples shown will help you to understand tone. Take some card and try them for yourself using black (mixed) and white and monochrome with, say, Burnt Umber and White. Experiment with different arrangements, introducing your own designs, and then tackle some simple monochrome studies working from life or from black and white photographs (such as newspapers).

Black (mixture of Ultramarine, Cadmium Red and Permanent Yellow) and White provide the extreme in tonal contrast. The tonal extremes of a painting may not be so far apart as this.

Black, white and mid-tone grey. There will be other tones either side of this middle tone increasing in either darkness or lightness towards the extremities.

An arrangement showing how contrast diminishes the closer the tones are to the extremities. Compare the two extreme tones at the top with the bands at the bottom.

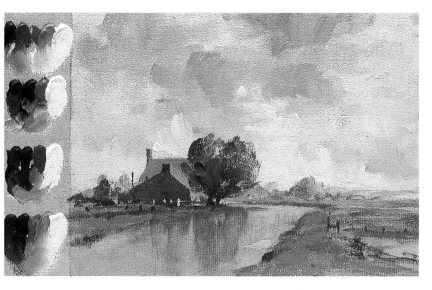

After The Shower *The farm and tree are contrasted against the clearing sky in this rather loose treatment. The gable end and tree, together with the lower sky, form the tonal extremes. The tonal contrast between fence and gable end provides an important accent of detail at this point. Mid-tones – in the clouds, roofs, distant trees, wet road and fields – combine to provide tonal harmony.*

The study was painted on a canvas board with Burnt Sienna wash ground. To the left you will see the mixes used for the various elements, with paint selected from my basic arrangement of fourteen colours. My palette in this instance was restricted to six colours plus white.

The colours Ultramarine, Burnt Umber, Venetian Red, Crimson, Raw Sienna, Yellow Ochre and White were used in various mixes for sky, trees, buildings and road, then fields. Such mixes will be described, but in more detail, throughout the book.

Rothenburg, Germany *This magnificent, walled town in Bavaria possesses many cameos and delightful subject matter on a grander scale. It was the subject of a visit during our stay in Germany to paint for an exhibition at Bad Homburg, Frankfurt.*

This monochrome study of the continuous covered walkway along the inside of the ramparts guarding the town is painted with Burnt Umber and Titanium White on canvas board, prepared with a ground wash of Burnt Sienna.

Tonal extremes were registered first, sky and underside of roof, followed by a range of mid-tones. Note how the comparatively small but dark tonal area is balanced by the larger but varied lighter tones.

Although the area of white applied to canvas board is larger, the placing of the black combined with the heavy textured brush application, produces an overall balance.

I have reversed the roles of the tonal extremes. This illustration and the one above indicate in a simple way that tonal areas do not have to be equal in order to produce tonal harmony.

Summary

- It is important that you learn to assess tonal values and transmit them to your painting. Sketch whenever you can. Charcoal is a very good medium as it can be used in a painterly way, similar to pastel.
- Make monochrome studies in acrylic. These, like black and white photographs, will, through dispensing with colour, help you to concentrate on tone.
- With practice and observation, you will soon be able to recognize tonal differences when considering colour. It will help to squint your eyes when looking at a subject. Your eyelashes act as a filter, and tonal contrasts are thus exaggerated.
- Register lightest lights and darkest darks, and then follow with mid-tones, aiming all the time for tonal harmony.

Tonal Studies

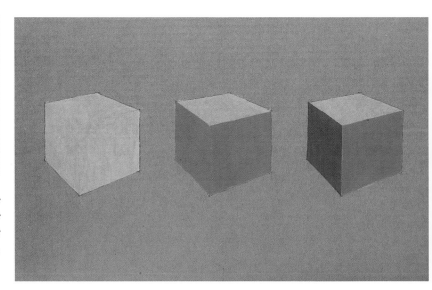

Tone assists in accentuating the shape of objects and on these pages I have shown how to draw and paint the four basic forms: the cube, the sphere, the cone and the cylinder.

The Cube *Draw the cube in perspective with the horizontal lines/ edges directed towards their two vanishing points (see page 21). The light source is coming from above and to the right. Mix just a touch of Burnt Umber with White and paint all three exposed sides of the cube. This will represent the lightest tone. Then adding more Burnt Umber to the same mix, paint two vertical faces with the mid-tone. Lastly, produce a strong mix and paint the side in full shade. The three faces show light and dark tones with a third mid-tone.*

The Sphere *Draw a circle and apply a flat mid-tone. Use a stronger mix for the area on the lower left side which is in shade. Finally, paint the light side (with highlight) and the area of reflected light (bottom left).*

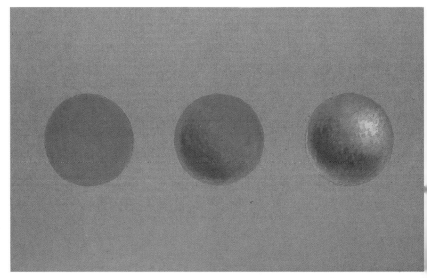

The Cylinder *Draw two ellipses spaced apart, with the help of the one vertical line and two horizontal lines as shown. Perspective causes the upper face, or ellipse, of the cylinder to appear less rounded than the bottom ellipse. The half segments of both ellipses furthest away will be narrower than those nearest to you. This is called foreshortening. Paint a light tone on the top surface, a mid- tone to the vertical surface and a dark shade to the left, blending with the mid-tone. Add light tone to the vertical side with highlight, and then reflected light on the left side.*

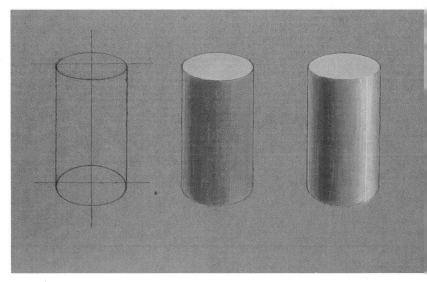

The Cone *Draw an ellipse as before and join outer edges to the top of an extended vertical line to form a cone. Paint a mid-tone, and then apply the dark tone on the shaded side as shown. Finally, add the lightest tone on the right and indicate reflected light on the far left.*

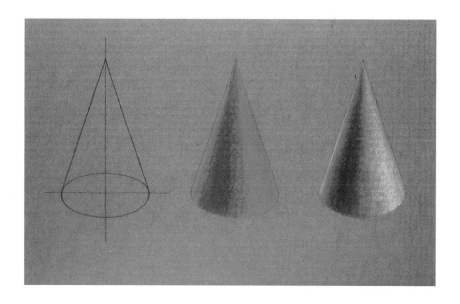

All of these exercises demonstrate how dark, medium and light tones combine to accentuate the three-dimensional qualities of these forms, and provide a vehicle for representing them with the two dimensions available to the painter.

Familiarize yourself with these shapes and practise drawing and painting them, for they appear in all sorts of guises in most subject matter.

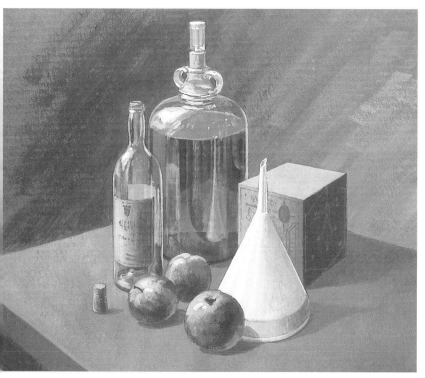

Still Life for Home-Made Wine Buff *This study shows not only how the qualities of tone help to define the shape of objects, but also how tonal values express the relationship these objects have with one another when brought together to share in the play of light. See how the shaded edge of the foreground apple contrasts with the white funnel, and how the light edge of the funnel in turn contrasts with the shadow and base of the jar. There are many subtle half tones and sharp highlighted accents.*

We are avid hedgerow-wine fans and I assembled a few items including a box kit to represent the cube, sphere, cylinder and cone.

Summary

■ All objects have areas of dark, medium and light tones, and these help to define the shape and form.
■ Look at household or garden items based on the four basic forms and study the play of light, and the formation of tonal values.
■ Make sketches using acrylic, or use charcoal to achieve more rapid and direct notes. The principle is the same whichever medium you use.

BASIC TECHNIQUES

In this section, I have included seven ways of applying acrylic paint to the canvas. There will be others later on, but for now these should keep you busy before we discuss further materials and their uses.

When you have mastered these techniques you will be able to approach a subject with more confidence, and apply your whole effort towards artistic expression. It will be like driving. You will be able to perform functions almost without thinking and if there is a problem with your vehicle, sound technical and mechanical knowledge will be a bonus in helping you to reach your destination.

Line

This technique, like the remaining six, can alone be used to create a painting. More often than not, however, it is incorporated when the subject demands it, as an integral part of the overall rendering.

DRAWING

A thin mix of acrylic paint is fine for drawing, using a round brush. Like drawing inks, the paint is completely waterproof once it is delivered and dry. Using sound drawing techniques, such as cross-hatching, and broken and expressive line, full renderings can be achieved. Brush is particularly good for an expressive line.

PAINTING

Line-strokes will appear in monochrome or full-coloured work in many

Expressive line, using a round brush
By varying pressure when applying the brush to the support, you will produce an expressive line. Heavy pressure will produce a thick line whilst a light touch will deliver a thin line.

Expressive line, using a flat brush
Line strokes of varying widths can also be achieved with a flat brush, by changing the angle of the brush and direction of the stroke. Use your synthetic flat No. 8 brush.

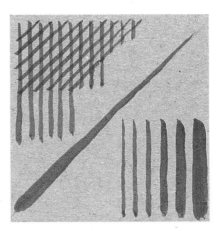

Hatching *Strokes placed side by side can be used for shading and, by increasing in width, suggesting shape and perspective. Cross-hatch for darker tones. Expressive line (centre) suggests perspective.*

Line

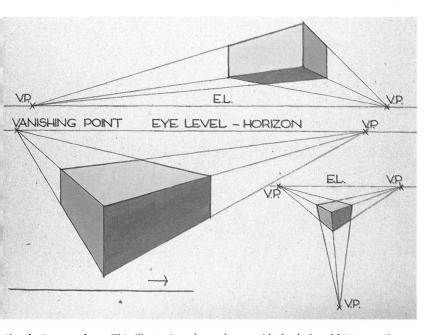

forms. Used as an underdrawing, the strokes can be effectively allowed to show through in the finished painting. They can be used in a similar manner as the work progresses to define shapes as an integral part of the design.

Lines of varying widths are employed during the course of a painting to depict trees, from trunk through branches to twigs, grasses, fencing, telegraph poles, brickwork, boarding and so on. It is normally sufficient to suggest these shapes and textures with the brushes, depending on the artist's approach. Final highlights are often added with a rigger brush.

Simple Perspective *This illustration shows how, with the help of faint pencil guidelines a fine constant line can be produced using a round No. 3 brush. The tonal values of the forms were painted with a flat No. 4 brush. If you look carefully, you will see that the long lines are not continuous but broken at a point where the brush has been refilled. It is better to have a break than a blob. If you are right-handed, draw from left to right, see lower left. The diagrams show that all parallel lines converge and meet at a vanishing point along the horizon (viewer's eye level), whether they are above or below this level.*

Cylinders and Streets *A circle or cylinder in perspective is not so difficult to comprehend if you remember the following: a line drawn through the centre of a cylinder along its axis (say, a roller, or pair of vehicle wheels, as they represent the ends of a cylinder) is always at right angles to a line drawn through the centre of the ellipse. Note the foreshortening of the ellipses as described on page 18. The diagram to the right shows a typical street perspective with the vanishing point at eye level. The buildings are all shown parallel. If this is not the case, lines that are horizontal will have their own vanishing points along the eye level (horizon).*

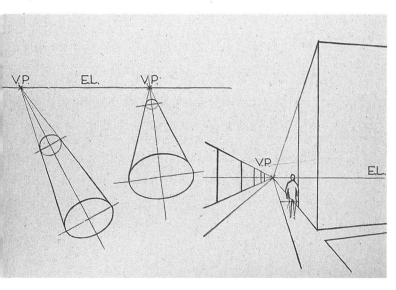

Further Notes On Perspective

There are three types of simple perspective:

1 One-Point Perspective. If we take a cube as an example, and place it so that only two faces can be seen, the top and the side, the one set of receding parallel lines that are visible will only need one vanishing point.
2 Two-Point Perspective. Providing it is near to eye level, a cube with three faces visible presents two sets of apparently converging lines. Two vanishing points are therefore required (*see* top left).
3 Three-Point Perspective. If the cube is well below or above eye level, vertical lines also appear to converge. Assuming three faces are again visible, three vanishing points are required (*see* top left).

Demonstrations in Line Technique

The following step-by-step demonstrations indicate how a thinned acrylic paint mix can be used to produce a waterproof drawing. Various line-strokes are used in both studies which are quite different in form, one rather angular and the other rounded and sculptural. If you are working outside, then an acrylic retarder added to the mix will prevent the paint from drying too quickly (*see* page 44). The brush must be kept moist so as to maintain the flow of paint: do not allow the acrylic to dry on the brush.

Draw and sketch subjects which require similar line-strokes. Your own street or road will do; you don't have to travel far. Instead of weather-beaten granite rocks, a coat hanging on a hook or drapery will provide rounded and curved surfaces.

Use an expressive varied line, breaking it along points where light falls on the subject to indicate highlights. Use hatching in the same plane as the surface before you. Follow the curves and contours to express the shape. Use line to suggest texture.

Church Street, Steyning, West Sussex – Step-by-Step (1–2)

MATERIALS For Step-by-Step

- Grey mounting card.
- HB pencil.
- Acrylic paint: Ultramarine Blue, Burnt Sienna.
- Small pot for mixing.
- Sable round No. 4 brush (synthetic round No. 4 would do).

Step 1 *A good example of a street with an interesting skyline and buildings producing all sorts of angles and textures. The slight rise and then fall of the street adds interest. Note that the head of the figure on the right is a little higher than my eye level because she is further up the rise. Figures at the far end are lower because of the fall in the pavement at that point.*

I ghosted the general composition before drawing the outline of the buildings and main elements. A broken line was used to describe the edge of sunlit surfaces.

Step 2 *I put in the darkest darks (openings) before applying expressive line to the various elements, drawing lines nearer the foreground with a heavier weight to enhance the feeling of perspective. I then set about adding detail to the buildings. Vertical lines with diagonal hatching portray the framework of the jettied timber-framed building on the left. Brickwork, craggy roof tiles, boarding, plinths, window sills and kerbs all provide a strong linear and directional emphasis, emphasizing the perspective.*

Cross-hatching, horizontal, vertical and diagonal hatching was used for the shadows. Note how the hatching lines follow the fall of the pavement and camber of the road.

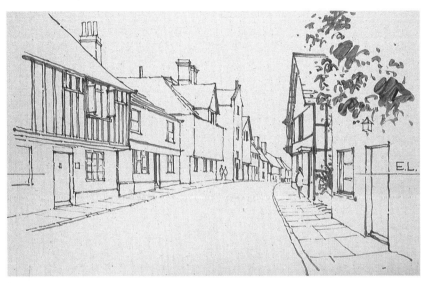

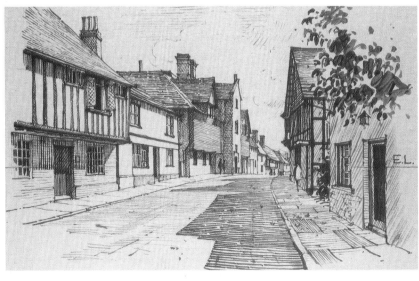

Pulpit Rock, St Mary's, Isles of Scilly – Step-by-Step (1–3)

MATERIALS
For Step-by-Step

- Canson Mi-Teintes 407 paper.
- HB pencil.
- Acrylic Paint: Ultramarine Blue, Burnt Sienna.
- Small pot for mixing.
- Sable round No. 4 brush (synthetic round No. 4 would do).

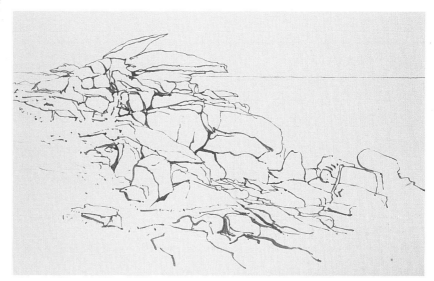

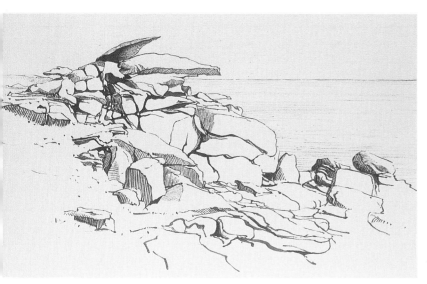

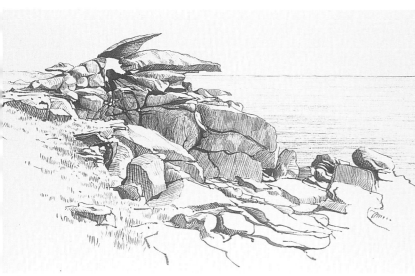

Step 1 The islands, one step removed from the West Penwith, are another spot of which my wife and I are extremely fond. Flower fields enclosed by tamerisk, escallonia and pittosporum create patterns running down to the white beaches edged by sun-bleached and wind-sculpted granite. Pulpit Rock is one such glorious pile, and I first registered the general form with a carefully drawn expressive line.

Step 2 I registered the darkest darks with lines following the contours of the granite. Some of these were so close as to produce a solid block of paint. Strokes can nevertheless be seen to follow the direction of the surface depicted.

I indicated the calm sea with near-horizontal strokes indicating the plane and direction of currents. I then began building up the form of the granite slabs by hatching the shaded areas, always following the angle and curvature of the surface.

Step 3 I continued to work on the shaded areas, gradually firming up the shape and mass of this naturally produced sculpture, for this is how the magnificent spectacle should be described.

Short, near-vertical and economic strokes were used for the sunlit grass by indicating the lightly shaded creases over the surface only. Some folds on the sunlit granite were similarly treated, but most such as those in the foreground, were left alone. Understatement is better than fiddly fussiness:

23

Impasto

Impasto is the application of thick layers of paint to give a textured surface. The extent to which this can be achieved ranges from subtly raised surfaces characterized by brush marks to heavy renderings of paint squeezed straight from the tube. Jackson Pollock produced much of his work direct from the container. Many other contemporary painters work in the same manner, including John Bratby.

The Advantage of Acrylics

Acrylic paint has become extremely popular with artists who work in impasto. The quick drying time and strong adhesive power of the medium makes it most suitable for laying on thickly. Oils of course have been, and are still used for the technique, but the slow drying time and problems of dust and dirt collecting on the surface during this process, and perhaps most of all, cracking in the case of heavy applications, render this medium less suitable. Acrylics on the other hand, even when applied straight from the tube, dry much more quickly than oils, do not crack (as they are very flexible) and dust is not attracted because of the hard film that quickly forms.

Ways of Applying Impasto

There are many methods of application: brush, palette knife, straight from the tube, sponge, and even the finger. I have dealt with the use of the brush on these two pages. Other methods are shown under the materials and acrylic painting technique sections.

Cryla Acrylic colour used without the addition of water or medium is fine for impasto work. The buttery type consistency retains brush strokes admirably.

Acrylic texture paste can be used to build up in impasto, but personally I do not feel its use permits the natural flow of brush painting. The process is described in the Texture Paste section on page 40.

Impasto *The building up of layers, each successive application producing texture, accentuated by brush marks. Strokes follow form in this rendering of a vegetable shape using Ultramarine, Burnt Umber, Burnt Sienna and Permanent Yellow.*

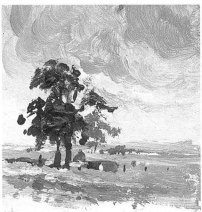

Tree *Impasto can be used to accentuate an area of interest against a thinly painted background. The tree, barn and foreground were thus treated using Ultramarine, Venetian Red, Yellow Ochre and White.*

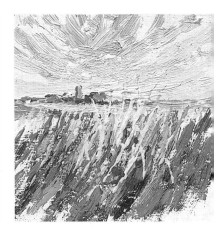

Norfolk *An impasto treatment throughout. Sky, trees, and church were painted thickly and the foreground was built up in textural layers and finally with directional line-strokes. Ultramarine, Cadmium Red, Yellow Ochre, Permanent Yellow and White were used.*

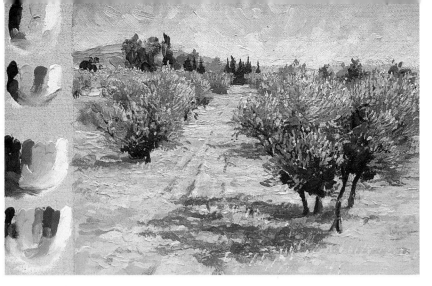

Example: Olive Grove, Les Alpilles, Provence *Provence is perhaps my favourite painting ground and these olive trees provide the perfect study to illustrate the use of impasto to accentuate their textural quality.*

The following mixes were used (left, from the top down): sky – Ultramarine, Permanent Yellow, White; hills and distant trees – the previous colours plus Crimson; olive trees – Ultramarine, Burnt Sienna, Raw Sienna, Cadmium Yellow Deep, Permanent Yellow and White; ground – Ultramarine, Cadmium Yellow Deep, Permanent Yellow, Yellow Ochre, Venetian Red, Crimson and White.

The sky was painted first, then the hills, followed by the darkest darks to the bases of the olive trees, which were built up in short heavily textured directional strokes over the broadly applied base.

Summary

■ Impasto refers to thickly applied paint producing various textures.
■ Brushes, palette knives, sponge, or the finger, may be used and the paint can, if you wish, be squeezed direct from the tube.
■ Work paint in the direction of the shape or contour.
■ Impasto can be built up immediately, i.e. wet in wet, or in layers over a thinly applied base.
■ Use acrylic paint without water or medium.
■ Texture paste can also be used (*see* page 40).

Trees and Barn – Step-by-Step (1–2)

Step 1 *The following mixes were used (from the top left down): sky – Ultramarine, Venetian Red, Yellow Ochre, Crimson and White; trees – Ultramarine, Yellow Ochre and White; barn – Ultramarine, Venetian Red, Yellow Ochre and White; fields – Ultramarine, Monestial Blue, Raw Umber, Yellow Ochre, Crimson and White; grasses, etc. – Ultramarine, Burnt Sienna, Yellow Ochre, Cadmium Red and White.*

The whole subject was registered with an underpainting thinly applied and loosely executed.

Step 2 *I worked over the sky, with a well-laden brush, darkening the base of the cloud (Ultramarine, Venetian Red and White) before working on the lighter areas (Yellow Ochre, Crimson and White). I then applied impasto to the trees, building up texture in the direction of the form and darkening the darks. The barn was similarly treated with the appropriate mix. The fields were painted in horizontal movements, then the foreground, the two dead trees and the grasses were applied with thick line-strokes to produce a textural relief.*

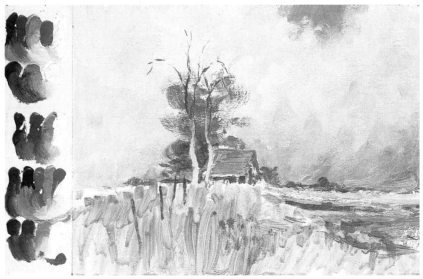

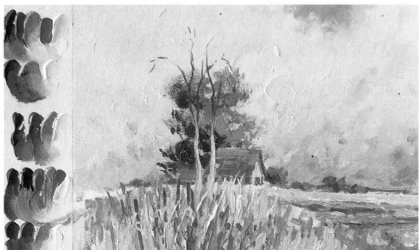

Thin

There is a school of thought that acrylic paint, being such an exciting and comparatively new medium, should only be used in new and innovative ways. Furthermore, it is considered by some that its use in a traditional manner is a backward step unworthy of its true potential. I agree with this to a certain extent, but there are certain traditional and more recent techniques where, through the use of acrylics, qualities are displayed that are an improvement upon traditional materials, such as its use for glazing and heavy impasto. I believe the medium should be used to stretch the potential of all methods, both traditional and new, to the limit.

Watercolour Technique

When referring to thin as a technique, I am really considering acrylics as being applied to the support in the manner of a watercolourist in broad terms only. I say broad because, as a pure watercolourist, I do not use opaque white. One of the advantages of acrylics, however, is its versatility in being able to offer both translucent and opaque paint from the same tube.

Examples of thinly applied acrylics appear throughout this book, using mediums, glazes, water and water tension breaker either individually or combined with other techniques – another sign of the paint's versatility. These methods are discussed under the sections entitled Glazing, Line and Wash and my Studio Technique.

I have shown on these two pages quite unashamedly how the translucent qualities can be taken to the limit and used to produce a pure watercolour. The paint has been applied in thin transparent washes in both the wet-in-wet method and after the preceding coat has dried. Watercolour paper has been used, and is expressed for the light passages, the opaque property of the acrylic paint being ignored. This method encourages directness, for unlike ordinary watercolour, when the paint is dry, it is waterproof and can be altered only with an opaque application.

MATERIALS
For Exercises and
Step-by-Step

- Saunders Waterford 638gsm watercolour paper.
- A large wash brush, either synthetic No. 20 or sable No. 12. Providing the wash brush has a good point this will do for suggesting detail. A No. 4 or 6 can, however, be used instead.
- HB pencil.
- Acrylic paint: Ultramarine Blue, Burnt Sienna, Venetian Red, Crimson, Raw Sienna, Yellow Ochre, and Permanent Yellow.
- China or plastic mixing trough for large washes (wash in water frequently). Staywet palette or plastic palette can be used for smaller mixes.

Exercises

Flat Wash *Wash of Ultramarine Blue plus plenty of water, applied with a full brush, working horizontally left to right and from top to bottom, as with watercolour.*

Graded wash *A wash applied in the same manner as the flat, but starting with a fairly strong mix and adding more water with each horizontal application to lighten the colour towards the base. Useful for skies.*

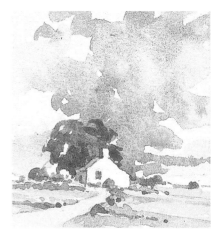

Small Study *This small sketch demonstrates the clarity and liveliness that can be achieved using acrylic to produce wet-in-wet washes for the sky, and a fully laden brush over dry passages for trees and foreground.*

Zennor, Cornwall – Step-by-Step (1–3)

Step 1 *HB pencil lightly indicated the general form. The sky was painted first with a wash of Yellow Ochre plus Crimson over the areas of light cloud down through the horizon and sea. Ultramarine wash was then worked for the blue passages from the top and lightening down through the sky painting wet in wet. Harder edges are left where the acrylic paint had dried underneath. Swiftly, I applied the shaded side of the cloud with a wet in wet wash of Ultramarine and Venetian Red. The mix used for the sky and sea is indicated top left.*

Step 2 *Burnt Sienna, Raw Sienna and Permanent Yellow were now used to complete the mixes for the rest of the painting (see left, second down from top). Yellow Ochre and Ultramarine were used for the distant fields and, together with Raw Sienna and Permanent Yellow, produced underwashes for the foreground.*
 In the distant fields I indicated hedges and trees with a darker mix before applying base washes to the buildings using Yellow Ochre, Raw Umber, Ultramarine and Venetian Red. The darks to the church complex were added, Ultramarine and Raw Sienna to trees, and Ultramarine plus Venetian Red to buildings and wall.

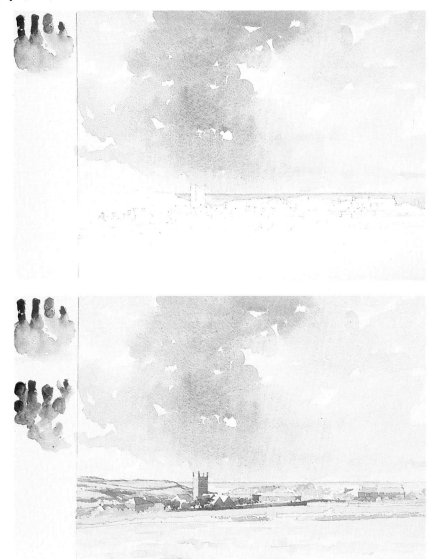

Summary

- Acrylic paint can be applied thinly in translucent washes simply by adding water. Acrylic gloss and matt mediums, glaze medium and water tension breaker can be used.
- Acrylic paint can produce clean transparent applications. The method can be used for a complete painting, but is usually reserved for paintings involving combined techniques, and works where the virtues of acrylics are exploited to the full.
- Remember the quick drying power of acrylic paint when applying thin washes, and also that the paint is waterproof.
- Mistakes can be eradicated with opaque paint.

Step 3 *I applied a wash of Permanent Yellow and Ultramarine Blue to the middle field and a broken wash of the same mix to the foreground. Further darks and details were added to trees, bushes and buildings, and the shaded hedges painted to accentuate the strong sunlight. Foreground shading and details were suggested with a mix of Ultramarine and Permanent Yellow, applied with a full brush.*

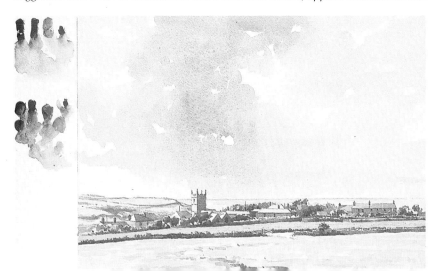

Dry Brush and Scumbling

MATERIALS
For Exercises

■ Canvas board with Burnt Sienna wash ground on acrylic primer.
■ Brushes: Hog bristle or synthetic flats, Nos 4, 8.
■ Acrylic paint: Ultramarine Blue, Burnt Sienna Venetian Red, Yellow Ochre, Titanium White.

For Step-by-Step

■ Canvas board (as above).
■ Brushes: Hog bristle or synthetic flat No. 8, filberts Nos 4 and 8, sable or synthetic rigger No. 4.
■ Acrylic paint: Ultramarine Blue, Monestial Blue, Burnt Sienna, Venetian Red, Raw Sienna, Yellow Ochre, Cadmium Yellow Deep, Permanent Yellow, Titanium White.

Some of the traditional terms concerning the application of paint overlap to some degree. Scumbling refers to the application of opaque paint over a darker colour in such a manner that the paint beneath shows through in an irregular manner. This can be done by stippling the paint with the brush held vertically or even with a sponge (*see* page 66). If the base layer is flat and without texture, then this method is fine for achieving a broken effect. Most surfaces have a texture of some sort, however, and another way of producing the same effect is to use the dry brush method.

Dry Brush

A fairly dry brush with unthinned paint (work out any excess on to your palette first) is dragged across a textured surface. This may be the canvas weave through a thin base layer, or a heavily applied impasto with brush marks. The paint will be deposited on the high points of the texture,

leaving the base coat to show through.

A type of impasto can be built up using this technique where one layer of thick paint is built up over the previous application, the texture allowing the preceding coat to show through. Great depth can be achieved using this method.

When To Use

The techniques can be used for simply producing textured effects; scumbling through the direct application of the method, and dry brush by highlighting the textural highpoints of the paint layer and support beneath.

The areas so covered are usually highlights within a painting, and one very good example is the ripple of water created by wind movement, as illustrated in the demonstration. The light tonal value of the plane receiving most light, such as on a sphere, is another example. The strokes should always follow the direction and contour of the surface.

Exercises

Basic Stroke *First brush paint horizontally and thickly with bristle brush, using dark mix Ultramarine and Burnt Sienna. Then, when dry, drag a light colour mix down across the textural brush marks.*

Highlights *Paint a sphere (see page 18) with the bristle brush and a mixture of Ultramarine and Venetian Red. Use curved strokes to follow the contours. Apply highlight by dragging a dry mix of Venetian Red plus White, across the brush marks.*

Dry brush over impasto *Drag a dry, light mix of Ultramarine and Yellow Ochre over a dark impasto of the same colours. Do the same using White plus Ultramarine across a thinner application below depicting disturbed reflections.*

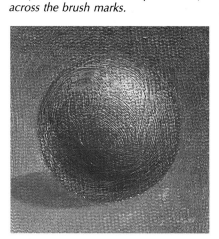

Lamorna Mill, West Penwith, Cornwall – Step-by-Step (1–3)

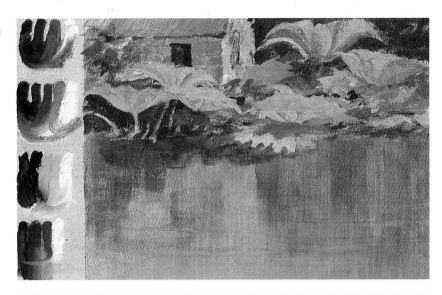

Step 1 *This old water mill set in the beautiful Lamorna Valley makes an ideal subject for painting from all angles. I am particularly fond of this aspect, looking across the mill pond to the giant 'rhubarb plants'.*

I first laid a base for the various elements using a mix of Ultramarine, Burnt Sienna, Raw Umber and White (top left) for the darks. Ultramarine, Burnt Sienna, Venetian Red, Yellow Ochre and White (second down) for the mill, and then Ultramarine, Monestial Blue, Cadmium Yellow Deep, Permanent Yellow and White were mixed for the plants. The thin base for the reflections was painted in downward strokes with a mix of Ultramarine, Burnt Sienna, Venetian Red and White.

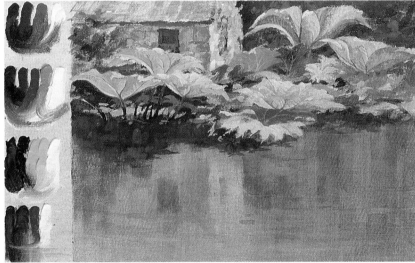

Step 2 *I suggested foliage detail to the rear with a fairly dark mix of Ultramarine and Raw Umber. More detail was added to the mill, slates, and granite work before firming up the structure and form of the plants. The sunlit, almost transparent leaves and shadows were worked up with light and dark mixes of Monestial Blue and Permanent Yellow respectively.*

Reflections were increased using the mixes for each element. Remember that reflections of dark objects are lighter in tone and, conversely, those of light areas are darker in tone.

Step 3 *Now to the main objective of this demonstration, and the stage where dry brush is normally applied, towards or right at the end. A gentle breeze was blowing, sufficient at times to disturb the surface of the otherwise still water.*

I first added the few grasses to the left and highlights beneath the plants before dragging a mix of White and Ultramarine horizontally across the water. With the brush and mix fairly dry, the paint rode on the high points of the canvas texture leaving the thin reflection mix to glow through.

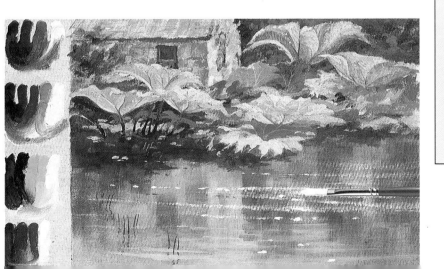

Summary

- Dry brush can be used most effectively both over heavily textured brush-marked impasto, and across thinly applied paint where the texture of the canvas is expressed.
- It is normally used for painting highlights and areas light in tone, and is applied over darker paint.
- Keep brush fairly dry and use a dry mix, i.e. without water or medium.

Wet In Wet

The title of this technique is a literal explanation of the process, albeit brief. The reference will require some elaboration but the words wet-in-wet describe precisely what is involved.

Colour is added to paint that is still wet and already on the canvas. Brushing wet paint into wet paint is an ideal way of blending colours. This can be done loosely to achieve a lively effect or subtly to produce a very smooth gradated blend. The cloud shape illustrated below is painted in a loose manner whilst the tonal changes on the sphere are smoothly registered. Painting into wet paint allows the colours to merge together more easily and evenly. A smooth change from dark to light can be achieved and in landscape work this is more generally applicable to sky and cloud studies. The blending to trees, shrubs, and vegetation is usually more loosely applied.

This method, particularly when working outside, induces a sense of urgency, a quick response to the effects of nature spread before you.

The quick drying time of acrylic paint means that you have to act quickly and apply your blending coat before the paint beneath has dried. As a result, there is little danger of your work becoming fussy and overworked.

For small and medium sized paintings up to 510 × 410mm (20 × 16in) paint can be thinned with water or acrylic medium, but for larger canvases you will need to use a retarder to slow down the drying time (*see Further Materials, page 44*).

Brush Strokes

The darker tones will usually have been applied first, followed by the lighter tones. These are blended into the darker passages with brush strokes that become lighter and more sensitive the smoother you require the blend, or transition from light to dark to be. Brush strokes should be applied with a semicircular motion for curved shapes, and straight for flat surfaces.

Exercises

Wet In Wet *Take any support, such as brown paper or card, and experience the placing of wet paint into wet paint. See how the paint blends, and use lively and subtle strokes in different directions.*

Subtle Gradated Blend *Using our old friend the sphere, apply the darker tones first and then the light shades and finally the highlight, painting wet in wet, and following the curved shape.*

Cloud Form *Paint this cloud shape with loose strokes. Try placing the darker tones, then the lightest, and blend with a medium to light tone. Practise using lively strokes to provide movement.*

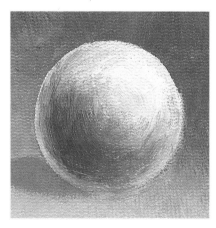

View from the Studio – Step-by-Step (1–3)

Step 1 We are fortunate to have this south-westerly view towards Dartmoor from our house. The studio is situated at the bottom of the garden with the north-light windows facing the house. The landscape looking south-east to the Whitestone hills is equally breathtaking.

For the purpose of this demonstration I decided to indicate the landscape first and then give my attention to the sky. The distant Dartmoor, fields, trees and buildings were painted wet in wet with mixes using Ultramarine, Burnt Sienna, Venetian Red, Raw Sienna, Permanent Yellow and White (bottom left).

I then started on the sky, registering the blues with Ultramarine plus Yellow Ochre and White with the mix greener and lighter lower down. The lighter area working up from the horizon was painted with Yellow Ochre, Crimson and White.

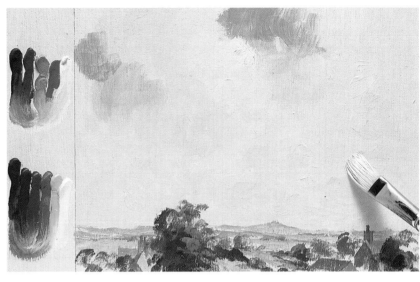

Step 2 Using Ultramarine, Venetian Red and White from the sky mix (top left) I rapidly registered the shaded areas of the cloud, blending with lively semicircular strokes of the filbert No. 8 brush, always following the billowing form.

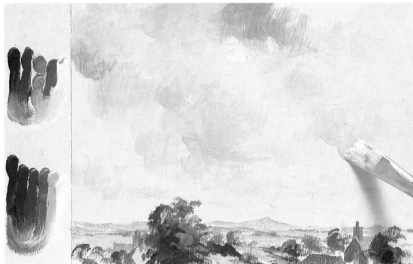

Step 3 Still using the mix of Ultramarine, Venetian Red and Titanium White, I further strengthened the cloud base and shaded areas, blending wet in wet continually and working quickly before the paint began to dry.

I changed the accent of the mix from a bluish grey to a reddish blue and back as appropriate during the course of painting the sky. Brush strokes varied from the vigorous to lighter and more subtle touches where the fusion and blending of the colours is more delicate, and particularly where the cloud is softest and lightest.

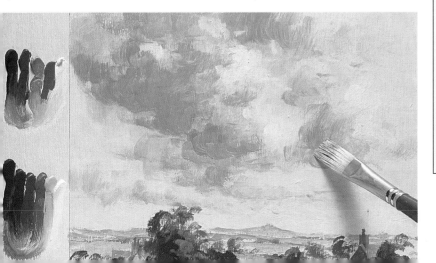

Summary

■ Painting wet in wet encourages a quick lively response to nature, because of the quick drying time of acrylic.
■ Use retarder for paintings over 510 × 410mm (20 × 16in).
■ Method allows colours to merge more easily and evenly.
■ Apply with a semicircular motion for curved shapes, and straight for flat surfaces.
■ Paint loosely to achieve a lively effect subtly to produce a smooth gradated blend.
■ Practise on inexpensive supports, such as cardboard.

Glazing

Glazing refers to the laying of a thin transparent layer or layers of paint over a previous, dried application of opaque paint. Acrylic paint is most suitable for this technique. It can be thinned down to the point where there is only the merest hint of colour. When using water to any great extent, some gloss or matt medium must be added to maintain the binding properties of the paint. The paint's quick-drying power enables successive layers to be applied without long waiting periods as experienced with oils.

Glazing can be used over the prepared support to form the composition and provide a thin base for building up the painting in, say, impasto, or even palette knife. It is used more often, however, to achieve luminous and vibrant effects by building up transparent layers of clean clear colour over an opaque base of light and usually white paint.

The technique was used by the old masters; now, technology has brought us acrylic paint, which is eminently more suitable for the method than were the materials that were accessible to them. Acrylic colours retain their clarity when thinned and, when used for glazing, produce effects of great vibrancy and intensity. Glazing using an acrylic glaze medium is discussed in the Further Materials (*see* page 42). Perfectly sound glazes can, however, be achieved using water and a few drops of gloss or matt medium.

Practice

Take some card and prime with gesso. Lay transparent coats of acrylic paint using the primary colours, and experiment to find out for yourself the effects that can be achieved. I have produced some examples for exercises below and the colour patterns, also based on the primaries and used in Support (*see* page 12), will help to form the basis for experimentation.

Exercises

Pattern One *Build up vertical and horizontal stripes over a white base using the primary colours. Note the subtle blends produced by the overpainting, resulting in many clear tints.*

Pattern Two *Horizontal and vertical L-shaped composition over an opaque white brush-textured square on Burnt Sienna washed canvas. Note how luminous the yellow and red become over the white paint.*

Pattern Three *Horizontal, vertical and diagonal stripes over Burnt Sienna stained canvas and white opaque base. Note how these base layers and textures affect the glaze.*

Garden Poppies – Step-by-Step (1–3)

Step 1 Our garden poppies provide a magnificent subject for about two or three weeks each summer. The glazing technique is the ideal vehicle with which to capture the luminosity of the sunlight shining on to and through the petals.

I drew the composition lightly in charcoal and then registered the darks, (the shrubbery behind). The colours (top left) illustrate the colours used: Ultramarine Blue, Burnt Sienna, Yellow Ochre, Cadmium Yellow Deep and Titanium White.

I laid an opaque white base for the poppies, with strokes following the form of each petal and leaving textured brush marks.

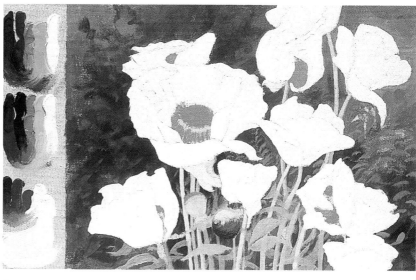

Step 2 The colours shown (bottom left) were used for the poppies: Ultramarine and Venetian Red for the centre, White for the base coat, and Cadmium Red, Crimson and Permanent Yellow for the petals.

I applied a glaze of Permanent Yellow to the petals using the synthetic brushes, and then, where the final red will be deeper, I increased the intensity with further coats. A glaze of Ultramarine and Venetian Red was painted over the centre.

Further attention was given to the stalks and leaves using Ultramarine Blue, Monestial Blue, Yellow Ochre, Permanent Yellow and Titanium White.

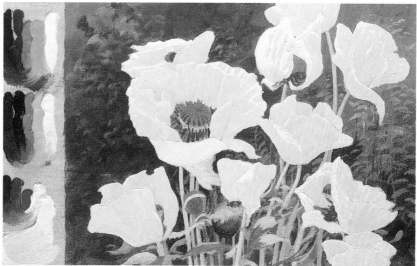

Step 3 This is the really exciting stage of the painting: the application of the red glazes. These darker coats bring to life the preparatory work. The brush marks of the opaque white ground layer are expressed where the glaze settles in the interstices of the texture, leaving the high points light in colour.

I continued to build up the layers where the tints are deepest until the correct balance was achieved. Further glazes were applied to the centres, again using Ultramarine Blue and Venetian Red, before final highlights were added.

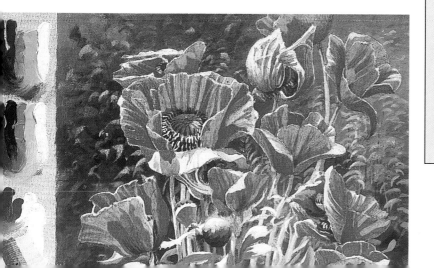

Summary

■ Glazing refers to the laying of a transparent layer of paint over an opaque base.

■ Paint can be thinned with the addition of water, acrylic medium or both.

■ Successive layers can be applied without long waits.

■ Textural brush marks in the base layer are accentuated by glazing layers.

■ Use a bristle brush for the opaque coats, softer sable or synthetic brushes for glazing.

Haze and Mist

MATERIALS
For Examples

■ Canvas board with a ground of Burnt Sienna light wash.
■ Brushes: Hog bristle flat No. 8 (top), and hog bristle fan shape No. 4 (bottom) (synthetic brushes can be used instead).

■ Charcoal.
■ Acrylic paint: Ultramarine Blue, Venetian Red, Yellow Ochre and Titanium White.

For Step-by-Step

■ Canvas board (*see* above).
■ Brushes (*see* above).
■ Charcoal.
■ Acrylic paint: Ultramarine Blue, Venetian Red, Crimson, Cadmium Red, Raw Umber, Yellow Ochre, Cadmium Yellow, Deep Permanent Yellow, Titanium White.

The distant haze and misty effects can be achieved through direct painting, usually with the wet in wet technique. Colours are blended to produce lighter tones the further away they are from the viewer. Blue greens, blue violets, and blue greys are introduced to convey the feeling of distance and, to create the haze or misty effect caused by the atmospheric changes, they are blended to merge together to the extent required. This requires subtle brushwork as described in Wet In Wet, *see* page 30.

Extension of Dry Brush

An alternative method of achieving the effect is to paint in the usual manner using gradated tones to suggest distance and then apply the mist with a dry brush, brushing the paint well out on the palette until it is dry, before working on the canvas. Use a bristle or synthetic brush No. 8 in a scrubbing action and the dryish paint will be finely distributed. The application will become thinner as the paint is used up and is excellent for the periphery of mist or fog patches where the background shows through. You will find that pressure of application must be varied according to the amount of paint on the brush.

Fan Brush

The same effect can be achieved using a fan-shaped brush. The paint need not be quite so dry as the more open arrangement of bristles allows more air to reach the paint thus permitting a drying out as the strokes are made. Brush out as before, as you need only a little paint, and work with quick, very light, semicircular strokes.

Avoid impasto and heavily textured underpainting where you intend to use this method if you can. Otherwise the strokes will pick up the high points and accentuate the object rather than achieving the intended effect, which is semi-concealment.

Practise both methods, remembering the feel and touch, for each is subtly different.

Cornish Mines *Cornish mist and drizzle applied over a tonally gradated underpainting of the two mines, the nearest being the darkest. The paint is applied extremely dry.*

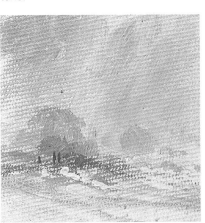

Trees *This sketch shows an atmospheric subject achieved through applying paint wet in wet and blended direct to produce a similar effect. Note the gradations of tone.*

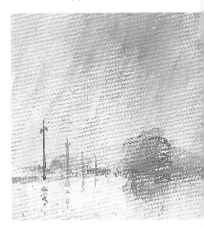

Long Wet Road *Fog and drizzle produced by a combination of wet in wet and ultra-dry brush techniques. The distant trees were painted wet in wet and the telegraph poles added with tonal gradations, before dry brush was applied.*

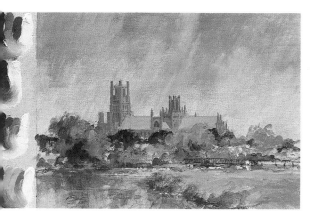

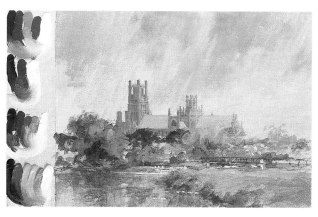

tep 1 *A particular atmosphere pervades this magnificent building, both inside and outside, even when viewed from afar across the fens. The drama is further heightened when the rolling fenland mist threatens to envelope the city.*

The sky was painted first using Ultramarine, Venetian Red, Crimson, Yellow Ochre, and White (top left). Ultramarine, Venetian Red and White (second down) were mixed for the cathedral. The buildings were suggested using these colours plus Cadmium Red and Yellow Ochre (third down). Ultramarine, White and all the yellows were used for the trees and field, painted in a loose free manner. Lastly the river and reflections were tackled with the corresponding colours.

Step 2 *The groundwork completed, I added the mist creeping in from the fens to the right. Applying a mix of Ultramarine Blue, Venetian Red and White with ultra-dry brush strokes, using the hog bristle flat No. 8, I started half-way up the sky. Working downwards I dry-brushed over the east end of the cathedral as far as the octagonal lantern. I enveloped the far trees, swirled the mist over the buildings beyond and to the right of the bridge. As the brush emptied, I feathered out the mist with soft edges over the trees behind the bridge. Finally, highlights were added to the water.*

Homeward · *The journey home is being somewhat marred by the weather conditions that often occur in north Cornwall and no doubt you will have experienced them. Thankfully there are many fine days that also contribute to the scenery, for without the changeable conditions the character would be different.*

This stretch between Bude and Holsworthy is usually quite windswept and I have portrayed the atmosphere of drizzle, rain and mist by painting partly wet in wet and then applying extremely thin ultra-dry brush. The colours used, which by now you should be recognizing from the illustrations, were as indicated (top left) for the sky and as indicated (below) for the landscape.

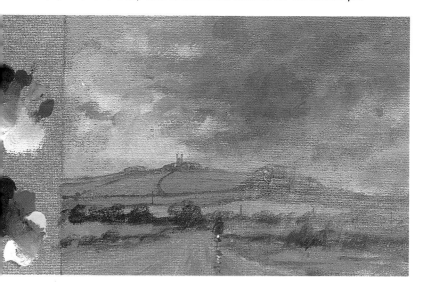

Summary

■ Misty and hazy atmospheric effects can be achieved by painting wet in wet. Alternatively, they can be obtained by using an ultra-dry brush technique.

■ Flat or fan-shaped brushes, either bristle or synthetic can be used.

■ Strokes using the flat brush can be vigorous, whereas the fan-shaped brush calls for subtle use.

■ Make sure the brush is dry and the paint well brushed out before applying to the canvas.

■ Feather out and soften the edges as the paint is used up.

■ Avoid working over impasto and heavy texture, as a general rule.

■ Wash the brush immediately after each passage, and dry before the next.

FURTHER MATERIALS

Checklist of Additional Materials

- Cryla Flow Formula paint.
- Water tension breaker
- Acrylic texture paste.
- Gloss medium.
- Glaze medium.
- Gel retarder.
- Masking tape.
- Further brushes.
- Painting knives.

Although acrylic painting can be practised quite satisfactorily using the basic Standard Formula paint, Cryla Colour plus water as the thinning agent, there are several ancillary materials (under the general heading of mediums), which are available to ease the task. You have already been introduced to the matt acrylic medium which can be used with or without water to thin the paint. Over the next pages I shall discuss the properties and potential use of the others.

Additions to the Basic Formula

The preceding pages in which I hav produced examples and suggeste exercises using the standard paint plu matt medium and/or water shoul have familiarized you with the pro perties of acrylics. I feel it is onl when you have experienced this basi practice that you can properly appre ciate the potential of these addition materials. I recommend that you tr them out and then decide which,

Flow Formula *The upper tube holds Cryla Standard acrylic paint which, by now, you will have discovered has a smooth, buttery type consistency that retains the stroke of brush or knife. The illustration shows the paint dispensed and worked with a painting knife.*

Cryla Flow, in the lower tube, has a more fluid formulation, ideal for underpainting, covering areas of flat colour and for hard-edge techniques (see page 54). With water or medium dilution, washes and glazes are readily achieved.

Cryla Flow is ideal for air-brush techniques and further information can be found in books dealing specifically with this specialist method.

Texture paste *This may be used to build up heavy impasto and should be mixed with glaze medium to give flexibility and prevent cracking if applied to canvas. It can be tinted or overpainted.*

Matt and Gloss Mediums *Mix with colour to produce transparent glazes. The gloss medium will give a gloss effect.*
Glaze Medium *The thicker nature of this medium adds depth to the glaze.*

Gel retarder *An acrylic additive to slow the drying time of the paint. It h. minimal effect on a colour's consistency but will marginally increase the transparency of the colour.*

Brushes and painting knives *An assortment of brushes and knives suitable for acrylics. Brushes (from left to right). Hog bristle fan shape, No. 4; filberts, Nos 12, 8, 4, 1; short flats, Nos 12, 8, 4, 1; long flats, Nos 12, 8, 4, 1; rounds, Nos 12, 8, 4, 1. Kolinsky sable: flat, No. 7; rounds, Nos 4, 1; rigger, No. 4. Synthetic: flats, Nos 14, 8; one stroke, size 10mm; filberts, Nos 14, 8, 4. Hog: long flat, No. 8; filberts, Nos 5, 2. Knives: palette Nos 92 and 94. Short trowel, small pear shape, narrow pear shape, medium pear shape.*

Buy the best that you can afford and with care and attention they will last you a long time.

not all of them, you wish to persevere with. You will not need to use them all the time, but each in its own way can contribute towards the perfection of a particular technique.

I have also shown a range of brushes and painting knives to give an indication of what is generally suitable for acrylic work.

The importance of cleaning brushes cannot be overemphasized. There is a school of thought that the less expensive synthetic brushes are more suitable for acrylic work. They are cheaper to replace and are very useful when painting thin, but for lose work, where brush marks are imperative, I prefer bristle.

Water tension breaker *This increases flow of paint to produce a completely uniform surface and reduce brush marks. Useful additive to help stain raw canvas.*

Masking tape *As well as being generally useful around the studio, masking tape can be used to form the true edge in hard-line painting, as demonstrated later on page 54.*

Summary

■ Having got the feel of acrylics, using Standard Formula paint mixed with water, you should now be ready to try these additional and supportive materials which, collectively, come under the general heading of mediums. Each will assist you to achieve a certain effect and it will be for you to decide how, when and where to use it to best advantage. Some you may decide not to use at all.

■ I will deal with their application in more detail over the next few pages. Advice concerning their use will be accompanied by step-by-step demonstrations.

Flow Formula and Water Tension Breaker

Flow Formula paint has a more fluid formulation than standard acrylic paint and takes a little longer to dry. The fluidity makes it ideal for underpainting, covering areas of flat colour and for hard-edge techniques. Even though the paint is very liquid it retains a similar density of colour. When thinned to the right consistency it is the perfect medium for air-brush techniques. The paint may be thinned with water or medium, as with standard acrylic paint.

To improve the flow of paint even further, an acrylic water tension breaker can be added. This will produce a completely uniform surface and reduce brush marks. It will assist the flow on to unprimed, porous surfaces where it is intended to retain this appearance, such as raw canvas. When applying paint in this way, one is really staining the support, rather than painting.

Applications

Flow Formula, with or without water tension breaker, can be used to create whole paintings either loose or hard edge, where textural interest is achieved through the support alone. Subtle differences can be produced by using thin applications with water tension breaker to stain some areas and by applying opaque covering over others. The medium can also be used in combination with other applications and techniques , such as staining, flat, impasto, dry brush and glazing, to produce paintings varying in depth and texture.

Practice

Prepare supports of varying textures such as mounted cotton, hessian, card and hardboard. Cover half with gesso and apply Flow Formula as shown. Discover how the paint and surface react to the admixtures.

Examples

Cryla Flow pattern on primed hessian
I primed the hessian, which was mounted on hardboard, with acrylic gesso, before completing this pattern using primary colours to show the finishes that can be achieved with Cryla Flow.

The bands of Cadmium Red, Permanent Yellow and Ultramarine Blue running left to right and down (incorporating Titanium White, thinned) were each divided into three and painted as follows: the first band (to the left on vertical; and bottom to horizontal) in neat Cryla Flow; the second, thinned with water; and the third, thinned with water plus water tension breaker.

Unprimed Hessian *The illustration shows Cryla Flow mixed with water and water tension breaker applied to unprimed hessian. The texture and surface appearance of the hessian is retained, beneath the red and blue. I applied a stronger mix of Permanent Yellow, and the weave here, although prominent, is somewhat more obliterated. The surface of the hessian has been stained, rather than painted.*

Form – Step-by-Step (1–2)

This study demonstrates how Cryla Flow can be used thinned, neat, combined with Cryla Standard applied in impasto, and glazed. I used unprimed hessian mounted on cardboard.

Step 1 *(right)* shows the hessian stained as an underpainting with Cryla Flow mixed with water and water tension breaker. Opaque Cryla white was applied to the central area.

Step 2 *(below)* shows the completed painting with Cryla Flow applied over the underpainting using dry brush and thicker applications. Impasto with Standard Formula was applied with a brush to lower areas and with a painting knife to the centre. This area was then glazed.

Texture Paste

Texture paste is an acrylic polymer extender for building up heavy impasto textures. It dries and hardens rapidly and is extremely adhesive. It is, as the name implies, a thick white paste. You will find it a very useful addition to your studio equipment for it can be used for restoring ornate picture frames and can be carved and sanded when hard and dry. Its adhesive and moulding qualities make it ideal for collage work.

Application

It is available in a 250ml container and can be applied with a brush or painting knife (*see* illustrations below) or indeed by any other means you may care to experiment with.

The paste can be applied direct to the support and then colour brushed in whilst still wet. Alternatively, form the shapes required, wait until dry, and then apply the colour. Paint can also be mixed with the paste on the palette and then transferred to the support. You will have to compensate for the whiteness of the paste both when mixing in this manner, and on the support. Further paint can be applied when the paste is dry.

The process does, I feel, interrupt the flow when using a rapid loose-brush technique. It is perhaps more suitable for heavy impasto work.

Summary

- An acrylic polymer extender, texture paste, can be put on very thickly. When used on canvas however, it should be mixed with glaze medium to give flexibility and prevent cracking.
Apply direct to canvas, and then add paint whilst still wet or wait until set before brushing on colour, or mix with paint on the palette and then apply. With all three methods further painting work will usually be required. Can be used for modelling and collage work.
- Practise these techniques and as you become familiar with the way the material behaves, experiment and discover other forms of application.
- Acrylic polymers can be extended in an almost limitless way, so the possibilities for discovering innovative approaches are endless.

Practice

Apply paste using the techniques a described and use studies where the heightening of texture will enhance the subject, as in the ploughed field opposite. Experiment and find other ways of using texture paste. The prospect of discovering new ways of expression are unlimited.

Examples

Texture paste applied to the support with a brush, and then a brush loaded with paint pushed into and dragged through the paste. Allow for lightening effect of paste on paint.

Texture paste and colour were mixed together on the palette and then transferred to the support, with painting knife or brush as shown. Apply further paint to darken and provide highlights.

Texture paste was applied to the support with a painting knife, shaped, and then painted over when dry and hard, using a brush. Darken where required and add highlights.

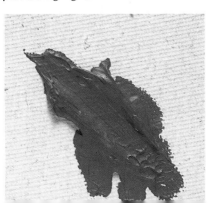

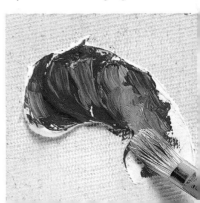

Ploughed Field – Step-by-Step (1–3)

This field near Sampford Courtney with the heavily textured furrows, particularly in the foreground, provided an ideal subject to illustrate how texture paste can be used to heighten texture. Paintings produced using this technique should be hung with lighting arranged so as to gain maximum effect from the lively textured surfaces.

Step 1 Using Ultramarine and Burnt Sienna, I drew the general composition with a brush and then indicated the furrows before painting the sky with the colours shown (top left). The trees, buildings, and hedges (second down) were added and I used the mix shown (third down) to indicate the fields and grass.
I then mixed Burnt Sienna, Venetian Red, and Ultramarine together with texture paste (bottom left on the palette), and started to build up texture to the foreground.

Step 2 Applying the mix with a brush I followed the line of the furrows, building up a heavy impasto in the foreground and diminishing up the hill, thus emphasizing, the perspective. I did not try to aim for a final colour mix, but concentrated on establishing form and texture with a base colour upon which I could build later. I took care to mix a mid-tone in order to assist the final application. If the base was too dark or light it would mean more work and paint to achieve total harmony. I applied a darker mix to the hedge on the left with a painting knife.

Step 3 Heightening the textural effect already achieved with the texture paste and paint mix, I added the shade tones with Ultramarine and Burnt Sienna. The lighter tones and highlights were painted using a mix of Venetian Red, Yellow Ochre and Titanium White. Lighter tones were added to the hedge before final highlights, such as stones, were added to the furrows.

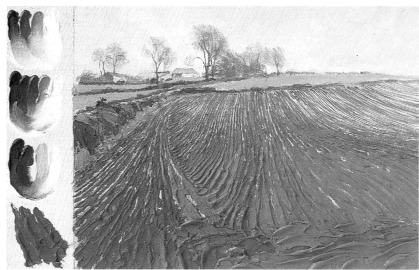

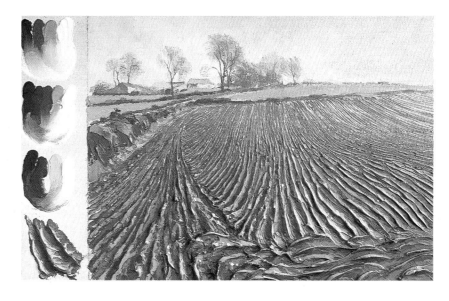

Mediums

MATERIALS
For Examples

- Gloss medium (60ml bottle shown top left).
- Matt medium (60ml bottle shown bottom left).
- Glaze medium (60ml tube shown on the right).
- Staywet palette.
- Brushes: Bristle, flats Nos 4, 8.
- Acrylic paint (for Barn): Ultramarine Blue, Monestial Blue, Venetian Red, Crimson, Cadmium Red, Yellow Ochre, Permanent Yellow, White.
 (for Crows-an-Wra, Cornwall): Ultramarine Blue, Monestial Blue, Venetian Red, Crimson, Yellow Ochre, Permanent Yellow, White.
 (for Cottage): Ultramarine Blue, Venetian Red, Cadmium Red, Raw Sienna, Yellow Ochre, Permanent Yellow, Titanium White.

For Exercises

- Gloss medium (*see* above).
- Matt medium (*see* above).
- Glaze medium (*see* above).
- Staywet Palette.
- Brush: Bristle, flat No. 8.
- Acrylic paint: Ultramarine Blue, Permanent Yellow, Cadmium Red.

Acrylic paints when used unthinned will dry to an eggshell finish. When mixed with water they will achieve a semi-matt quality. Various acrylic mediums can be mixed with the paint on the palette to produce different finishes. These can be used on their own for maximum effect, or they can be mixed with water.

Gloss Medium

An all-acrylic emulsion can be used with acrylic colours to increase the gloss effect. Up to 20 per cent of water can be added for glazing and thinning. It can be mixed with matt medium to produce a range of semi-reflective surfaces. It is quick drying and although milky white in appearance, it is colourless when dry, and water resistant. It also renders powder, poster and water colours water resistant in admixture, and can be used as a primer for raw canvas, board and paper. It is available in 60ml bottles or in 250ml and 500ml containers.

Matt Medium

Similar in appearance to gloss medium but provides a matt finish when dry. It can be mixed with acrylic paint, with or without the addition of water to produce transparent glazes. It is available in 60ml bottles or 500ml containers.

Glaze Medium

Possibly the most versatile of the mediums, as it can be mixed with acrylic colours to make them more transparent for over-glazing. The slightly thicker nature of the medium gives the final glaze an added depth. The more medium you add, the more transparent the colour will become.

This medium will also increase the drying time of acrylic colours. Its thixotropic nature makes it an excellent adhesive for collage and craft. It can also be used as a transparent primer. It is available in 60ml tubes and 500ml containers.

Exercises

Gloss and Matt Mediums *When using either gloss or matt mediums, dispense from the bottle on to the palette near the colours to be mixed.*

Gloss and Matt Mediums *Use your brush or palette knife to mix the colours, adding the medium from the reservoir alongside, and apply to the support.*

Glaze Medium *Squeeze some glaze medium on to the palette alongside the colours to be mixed. Use brush or palette knife to mix the colours adding the medium as you do so. Apply to support.*

Examples

Barn *This barn was painted with Standard Formula Cryla acrylic paint with gloss medium undiluted, that is without the addition of water. A gloss effect often heightens the liveliness where there are differences in surface textures. The blue-grey corrugated sheet roofing contrasts with the tiles and the texture of the tree foliage.*

If you look closely you will be able to see where the gloss finish accentuates the texture and highlights on the barn and foliage. This mix (top left) was used for the centre sky, the buildings and (bottom), the distant trees and foreground.

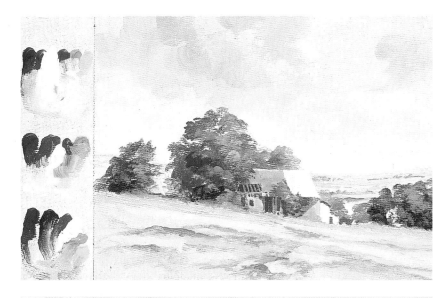

Crows-an-Wra, West Penwith, Cornwall *I felt that the mood, under the near clear blue sky, looking across to the last hillock before Land's End was best reflected by a matt finish, and so I decided to use the matt medium. I mixed very little with the paint as I did not wish to thin it down too much. Hardly any was used for the trees and hedges. The resultant matt surface induces the feeling of dry heat, stirred by the warm soft breeze, more so than a shiny surface would have done. The mix shown top left was used for the sky, and the lower mix was used for the landscape.*

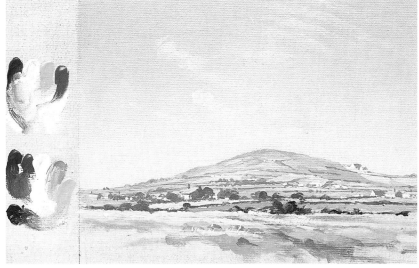

Cottage *This was just an exercise, more or less made up as I went along. I painted an opaque white base first, incorporating some texture paste in the foreground. The rest of the paint was applied in glazes using the glaze medium. The lighter colours were applied first, apart from the window; the darkest dark, together with the white gable, set the tonal range. I applied glaze upon glaze, using the colours shown to the left, until a balance was achieved. The more medium you use, the more transparent and luminous the glaze (this can be seen in the area below the window).*

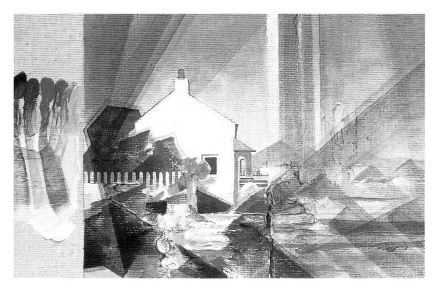

Gel Retarder

MATERIALS
For Step-by-Step

- Medium-grain cotton canvas, double acrylic primed, with ground of Burnt Sienna acrylic wash.
- Box easel (the box shelf provided a good support for the palette whilst I was standing).
- Two jars and container of water.
- Rag.
- Staywet palette.
- Brushes: Hog bristle flats Nos 8 and 4; filberts, Nos 8 and 4; sable rigger No. 4.
- Gel retarder.
- Charcoal.
- Acrylic paint (Cryla Standard Formula): Ultramarine Blue, Burnt Sienna, Venetian Red, Cadmium Red, Crimson, Raw Umber, Yellow Ochre, Permanent Yellow, Titanium White.

There are times when the quick drying power of acrylic paint can be a nuisance. We have discussed how valuable it can be when building up glazes, where it has a distinct advantage over oils in that one does not have to wait long before the next coat can be applied. Oils would, however, have the upper hand (particularly when used outside) for wet in wet work, if it were not for the acrylic additive gel retarder. Added to your palette, it can be used to slow the drying times of Cryla and Flow Formula acrylic colour, thus enabling you to blend colours on the support as you would do oils.

The medium is available in conveniently sized 60ml tubes to accompany the colours of your palette.

Properties

The medium has a minimal effect on a colour's consistency, but will marginally increase the transparency of the colour. Gel retarder can also be added to texture paste if a longer working time is required.

Wet in wet can be achieved without the help of this medium on supports no larger than 510 × 410mm (20 × 16in), particularly indoors, but if you are working outside, and in warm to hot, windy conditions it is essential to use gel retarder to keep the paint in a workable condition.

The demonstration shown on these pages was carried out in just these conditions, a warm, windy and, at times, sunny day.

Devon Fields – Step-by-Step (1–3)

I chose a view just above the studio and overlooking glorious red Devon fields, in the opposite direction to our view of Dartmoor. I am all set and ready to start with my palette laid out, including gel retarder. It is mid-afternoon and the sun is out with warm winds scurrying hazy clouds across the sky.

Step 1 *I squeezed some gel retarder on to my palette at one end. I usually put it alongside the white. I also tend to arrange the colours in the same order – it saves time!*

Gel Retarder

Step 2 I roughed in the general composition with charcoal, removed the excess charcoal dust with a light flick or two of the rag, and then set about the sky.

The cloud was being whipped up by the winds, creating pleasant wispy effects. I could see this was rapidly changing with the onset of less interesting bands of misty cloud so I quickly applied broad strokes of Ultramarine Blue plus White mixed with gel retarder. (Gel retarder was used in all mixes, so I won't refer to it again.) I added just a touch of Permanent Yellow to the blue further down in the sky. I painted the lower and middle sky with Ultramarine, Venetian Red and White to capture the blue grey cloud; and then mixing Yellow Ochre, Crimson and White, I painted the lighter wispy cloud, wet in wet, blending with the darker areas. I used the flat No. 8 brush for the whole sky, washing out the brush as I worked.

The darkest darks to the base of the tree (Ultramarine and Burnt Sienna) were registered before blocking in the fields and indicating hedges. I then blocked in the tree darks (Ultramarine plus Raw Sienna), and indicated branches with the rigger.

Step 3 Further blending was carried out to the fields using reds: Venetian Red, Cadmium Red and Crimson, plus Yellow Ochre and White; and greens: Ultramarine, Yellow Ochre, Permanent Yellow and White.

The farm buildings were suggested with warm and cool greys, and then the foreground field was indicated with Ultramarine, Yellow Ochre, Permanent Yellow and White, allowing the Burnt Sienna ground to show through, as elsewhere. Light tones were added to the trees and then highlights to the distant cottages, posts and grasses.

The gel retarder greatly assisted this wet-in-wet rendering of the windy scene, which was completed in just under an hour.

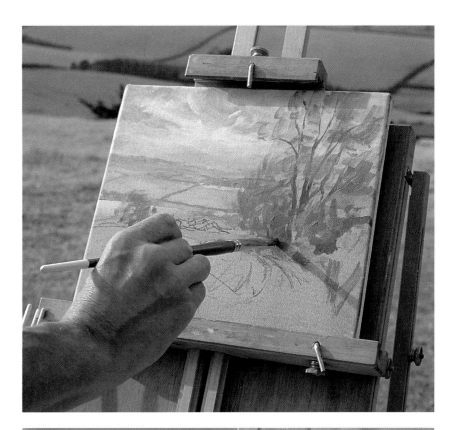

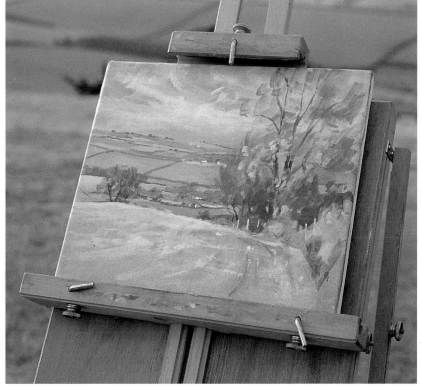

ACRYLIC PAINTING TECHNIQUES

MATERIALS

- Canvas board, with Burnt Sienna wash ground.
- Easel.
- Cloth.
- Water for washing brushes.
- Two pots of water for mixing.
- Gel retarder.

For Small Studies

- Brushes: Hog bristle short flat No. 8, filbert No. 8.
- Acrylic paint: Ultramarine Blue, Venetian Red, Raw Sienna, Yellow Ochre, Permanent Yellow, Titanium White.

For Example

- Brushes: Hog bristle long flat No. 12, short flat No. 8, long flat No. 4, filbert No. 4, sable rigger.
- Acrylic paint: Ultramarine Blue, Burnt Sienna, Venetian Red, Crimson, Cadmium Red, Yellow Ochre, Permanent Yellow, Titanium White.

In this second half of the book I shall be taking you through eight painting techniques which embody the application of the basic techniques dealt with in the first half of the book. Each technique is explained over a four-page spread, and introduced with an appraisal and a description of the materials to be used. This is followed by exercises or small staged studies, and a large worked example. I then take you through a four-stage demonstration, the subject of which is the same for all eight techniques. I have done this in order to facilitate a comparative analysis of the methods.

The subject I have chosen is not far from my studio. Pitt Farm lies in the magnificent mid-Devon hills between Crediton and Bickleigh. Many subjects abound here amongst the vibrant, red, ploughed fields and vivid greens produced by the rich grass.

Loose Brush

I have already covered this technique in some respects in the section on gel retarder (*see* page 44). It is a free,

Full-size reproduction of acrylic-primed canvas board with Burnt Sienna wash ground, used for the small studies and the example shown opposite.

expressive and open technique in which the brush is used to full advantage. The ability of Standard Formula acrylic to retain the brush stroke is exploited to achieve paintings which are lively in texture.

It is the technique I use most, and it is simply sheer joy to me, particularly when outside to record nature's many moods in this manner. Armed with

Bristle filbert brush No. 8
Expressive tapering stroke made with the filbert brush by first applying pressure and then tailing off whilst turning slightly. There are variations: experiment, investigate!

Bristle short flat brush No. 8 *The very distinctive mark of the flat brush stroke. It is so distinctive, one could become carried away and just dab away. It is ideal for underpainting and depicting flat surfaces.*

Example: Beaujolais Harvest at Fleurie, France

This is one of our favourite haunts in France where in late September the early autumn morning and evening misty haze seems to envelope the intoxicating aroma around each of the nine Cru vilages as the co-operatives begin pressing the grapes.

The composition was indicated using a thin mix of Burnt Sienna and Ultramarine, applied with the sable rigger. The sky was painted wet in wet using the flats Nos 12 and 8. The trunks of the vines (darkest darks) were positioned with the bristle filbert No. 4. The flat No. 4 was used for the buildings, and the filbert No. 4 for the vines, painting wet in wet. Strokes, in every case, followed the direction and contour of the surfaces.

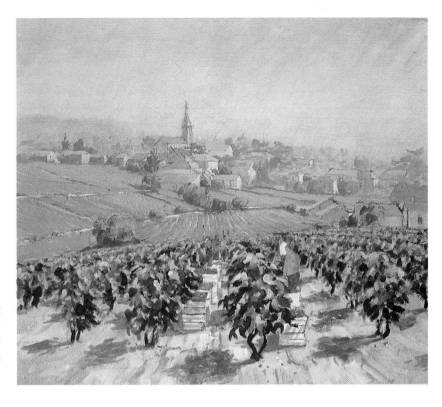

gel retarder, and painting mainly wet in wet, the adrenalin triggers an immediate response. For working in this way, acrylics encourage you to be less fussy and more responsive.

BRUSHES

Brushes are the most important items, as the name of the technique implies.

Follow form *This full-size reproduction emphasizes in an exaggerated way how form can be accentuated and expressed by following the direction and contours of the surface with your brush strokes.*

Bristle brushes work best for they impart the most lively texture throughout each stroke. Use the largest that can be conveniently handled for the size of painting. A selection of flats, filberts and a sable rigger to add highlights and suggest detail, will work well.

Exercise

Practise brush strokes using both flat and filbert brushes. Cardboard will do as a support. Experience how the bristles behave as you change direction and note the marks they leave. Build up compositions similar to the small study, using the brush strokes to indicate form with lively texture.

Summary

■ Loose brush is the free and direct application of acrylic paint where the brush is made to make the most of Standard Formula's capacity to retain the brush mark.
■ Use a selection of hog bristle flat and filbert brushes, for the stiffer bristles will produce lively and expressive textures.
■ Paint is applied mostly wet in wet, and other basic techniques can be incorporated, for example impasto, dry brush and glaze.
■ The loose brush technique will encourage you to be less fussy (if your work tends to be tight) and more responsive to the immediate.

Loose Brush

Pitt Farm in Loose Brush – Step-by-Step (1–4)

It was necessary for the purpose of this book to divide the demonstration paintings into four steps in order that you may see the progression from drawing through to the finished work. I would point out that paintings are not necessarily executed in this way, in stages with a line, metaphorically speaking, drawn under each stage. Loose brush is a very responsive technique, and I would usually work right through to completion (according to size). There is, however, a general order of operation, and the stages have been organized around this discipline.

For direct comparison, the same subject, Pitt Farm in Devon, has been used for all eight of the step-by-step demonstrations.

The farm with its cob walls, curved chimney breast, and thatched roof, stone and cob outbuildings with slate and corrugated iron sheet roofs is a typical example of a mid-Devon farmstead. Some are larger and grander with drives flanked by trees, but there are many smaller units like this spread all over the countryside.

The elements in this setting, the perspective of the field in the foreground, the trees and darks on the left, the farm, lane, trees in the middle distance and level area stretching to the distant hills capped by the sky in the upper third, provide sufficient depth of material for the eight demonstrations using different techniques. I prepared a master drawing which I transferred to the support in as much detail as the particular technique warranted.

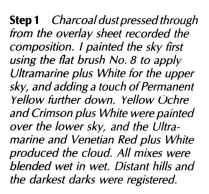

Step 1 *Charcoal dust pressed through from the overlay sheet recorded the composition. I painted the sky first using the flat brush No. 8 to apply Ultramarine plus White for the upper sky, and adding a touch of Permanent Yellow further down. Yellow Ochre and Crimson plus White were painted over the lower sky, and the Ultramarine and Venetian Red plus White produced the cloud. All mixes were blended wet in wet. Distant hills and the darkest darks were registered.*

Step 2 *I blocked in areas of the painting adding gel retarder as I mixed the colours. Top left indicates the sky mix used earlier. Ultramarine, Yellow Ochre, Permanent Yellow and White (second down) were used for the distant hills. Various greens with a blue tinge suggest distance and cloud shadows. Ultramarine plus Yellow Ochre plus White were mixed for the distant trees and hedges.*

I worked out of the painting using Venetian Red, Cadmium Red, Crimson, Yellow Ochre and White (third down) in varying mixes, sometimes darkened with Ultramarine for the red fields. The buildings and trees were then indicated.

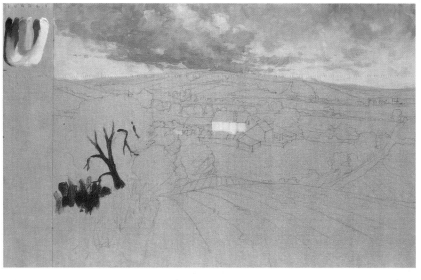

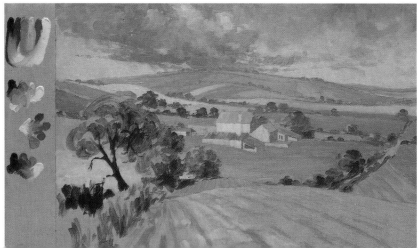

Loose Brush

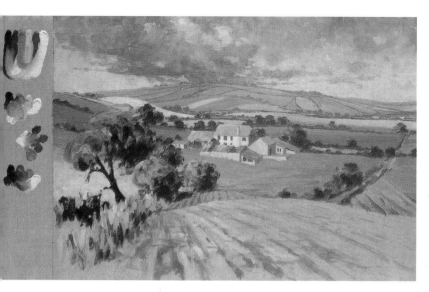

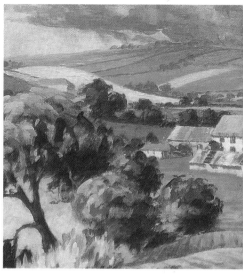

Step 3 *I went back to the middle distance, darkening fields with the same colours but adding Ultramarine, to register cloud shadows. I darkened the foreground and middle-distance trees and then added mid-tones to these and the hedges always following the shape with the filbert brush.*

Openings were added to the buildings, and the shaded parts deepened using Ultramarine and Venetian Red plus White, before I mixed Ultramarine, Venetian Red and Yellow Ochre plus White to suggest the perspective in the foreground, running left, and then back towards the farm in the lower field.

Enlarged Detail *The detail shows the brush strokes to the trees on the left. Note that detail is suggested and not painted in its entirety. Broad, loose strokes, but applied in a controlled manner follow the general shape of the trees in broad sweeps. The occasional small touch on the periphery suggests detail.*

Step 4 *Although I like to paint loosely, using the basic wet in wet technique throughout if I can, it has not been possible here because of the interruptions necessary for stage photography. A fresh lively approach can be maintained, however, by keeping brush strokes free and loose, and not tightening up.*

I deepened the cloud shadows by painting a glaze of Ultramarine and Yellow Ochre thinned with water plus matt medium. I paid particular attention to the shadow beyond the near field on the right, covering the light patch.

Shadows from the trees, and highlights were added using Ultramarine, Yellow Ochre, Permanent Yellow, plus Titanium White (lower left).

Summary

■ Work on the sky first, for the light emitted from this source, and influenced by the weather conditions, determines the mood of the landscape or subject before you.
■ Work wet in wet to blend the colours, with strokes following cloud shapes.
■ Fix the darkest dark.
■ Work from the rear of the subject and out of the picture blocking in the various elements.
■ Return to the distance and come forward adding darks to trees, etc, and repeat with mid-tones, then lighter passages, shadows and highlights.
■ Always follow shape and form with your brush strokes.

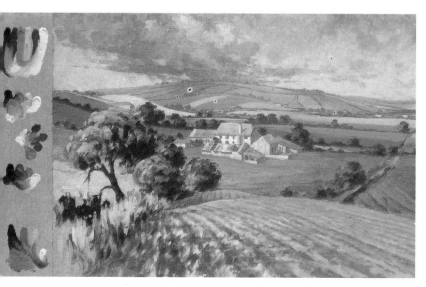

Line and Wash

This technique is really the coming together of two basic techniques described earlier: line and thin applications of acrylic paint. Comparative techniques include pen- or brush-

MATERIALS

- Saunders Waterford Not Surface, 638 gsm, watercolour paper.
- Easel.
- Brushes: Sable rigger No. 4, round No. 4, synthetic rounds Nos 3, 20.
- Board.
- Draughting tape.
- Cloth.
- Water for washing brushes.
- Two pots of water for mixing.
- Small jar.
- Gel retarder.

For Small Studies

- Acrylic paint (Standard Formula): Ultramarine Blue, Burnt Sienna, Venetian Red, Crimson, Cadmium Red, Yellow Ochre, Permanent Yellow.

For Example

- Acrylic paint (Standard Formula): Ultramarine Blue, Cobalt Blue, Burnt Sienna, Venetian Red, Crimson, Cadmium Red, Raw Umber, Yellow Ochre, Permanent Yellow.

Full-size reproduction of Saunders Waterford Not Surface 638 gsm watercolour paper, used for the small studies and the example opposite.

applied ink and watercolour wash, and coloured inks applied over a tonal inked base.

The examples shown here are fairly straightforward figurative interpretations of the subject chosen. I feel this is the best way of introducing you to the scope of the technique. Through practising the applications in a traditional manner, you can, when you have a feel for it, experiment using these two qualities of acrylic paint in other expressive ways. Line and wash can be combined with other acrylic techniques to produce abstracts – the options are limitless.

Sidmouth, Devon – Step-by-Step (1–2)

Step 1 *Newly paved, the centre of Sidmouth has been transformed. This delightful view towards the memorial and church has received full tonal treatment. Note the texture produced by the paper.*

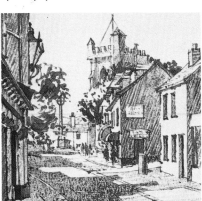

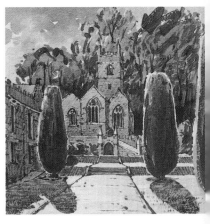

The Church, Lanhydrock, Cornwall
This view at the National-Trust-owned Lanhydrock House is highlighted by the halo effect produced by looking into the sun. The reflected light to the east end of the Church is an important relief.

Supports

With traditional work, a good stout watercolour paper works well. There is no need to prime or seal the surface. You can, if you wish, apply gloss medium as a primer. This stops the wash from soaking in to the paper and produces a lively floating effect. I prefer, however, to leave the paper as it is, allowing it to accept the water before drying out. This allows a more gentle blending of the pigments when

Step 2 *Colour washes are applied wet in wet and loosely to sky and trees. The buildings, paving and shadows were handled more carefully.*

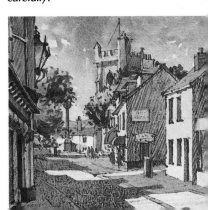

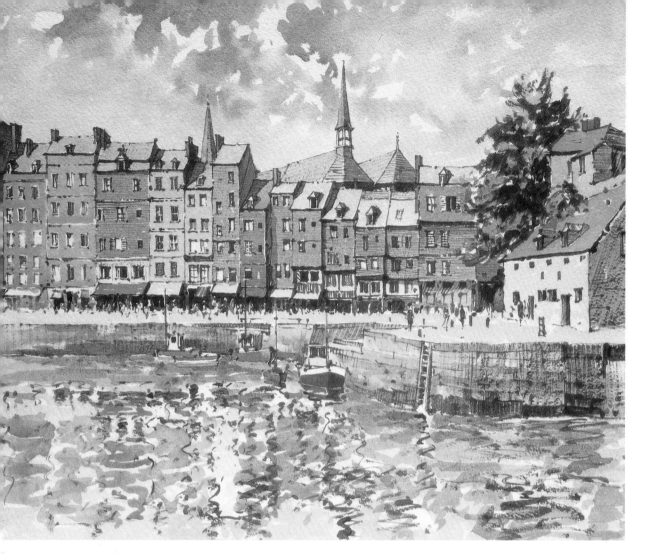

Example: Honfleur, Normandy, France

Line and wash is an ideal technique for catching the dancing reflections of the lofty narrow-fronted buildings in the harbour of this much-painted French town.

I made a careful but expressive line-drawing of the buildings using the round No. 3 and No. 4 for the darks (beneath the blinds). Other areas were more loosely drawn with the same mix, Ultramarine and Burnt Sienna. Reflections of openings and party walls were indicated with squiggles using the side of the brush. This brushwork provided a good base for the wash, for which the No. 20 round was used.

applied wet in wet. All surfaces primed with gesso primer will work well, and the various textures available will add interest to the wash.

Application

The line is usually applied with a round brush or rigger using a wet mix of, say, Ultramarine and Burnt Sienna, or any mix of your preference. Add a drop or two of gel retarder or add further water to prevent the mix from drying out. Produce a tonal rendering, capturing the subject with expressive line, complete with shadows registered using hatching and blocking. Then with a large round brush, say synthetic size 20, apply the wash over the drawing.

Summary

■ You can use paper unprimed, or any other surface, such as wood provided it is primed.

■ Mix paint for line-work in a small jar. Add a drop or two of gel retarder to slow the drying time, or add more water as you work.

■ Produce full tonal range with your line-work, including shaded areas and shadows, before applying wash with a large round brush.

■ Practise the traditional line and wash before experimenting with other interpretations, such as abstract. Many combinations are possible – for example, texture paste impasto with line and glazed wash.

Line and Wash

Pitt Farm in Line and Wash – Step-by-Step (1–4)

Before you flick through the pages to compare the demonstrations on a like-for-like basis, I will put your mind at rest now by revealing that they are not all exactly the same: the applications of the various techniques do not permit this. I have also, for the sake of my own sanity, changed the order of ploughing from time to time. The month of the year however is constant: June, when the earth has dried to produce vibrant reds, mixed here and there with fresh new growth pushing up through the clods, and complemented by greens mixed with yellow greens where early cutting has taken

place. All combine to produce a patchwork quilt sewn together by the roots of brambled and treed hedgerows.

SECURING THE SUPPORT

As I was using a heavy watercolour paper for the step-by-step demonstration, (638gsm), there was no need to stretch the paper (thin or lightweight papers need to be stretched to avoid cockling). I simply secured the corners with draughting tape. This is slightly more adhesive than masking tape. Better still, use surgical tape, which is available at most chemists and can be used several times over.

MATERIALS
For Step-by-Step

- Saunders Waterford, Not Surface, 638 gsm watercolour paper.
- Easel.
- Brushes: Sable rigger No. 4, round No. 4, synthetic round No. 20.
- Board.
- Draughting tape.
- Cloth.
- Two pots of water for mixing.
- Small jar.
- Gel retarder.
- Matt medium (add small amount to wash).
- Acrylic paint (Standard Formula): Ultramarine Blue, Burnt Sienna, Venetian Red, Crimson, Cadmium Red, Raw Sienna, Yellow Ochre, Permanent Yellow.

Step 1 *I produced a fairly dark mix of Ultramarine Blue and Burnt Sienna (top left) in the small jar and added two drops of gel retarder to slow the drying time in order to enable me to work through the drawing.*

When using ink or, as in this case, acrylic line, you can with practice charge straight in without preliminary pencil drawing. Lively and free effects are achieved this way, and generally the less pre-drawing you do, the better. Try simply to fix the general outline and proportions only before you start with the brush. I have done so here, using the master drawing as a guide. As a result, the eight studies do not match up, stroke for stroke!

I used the round brush No. 4, drawing with an expressive line altering the intensity to induce a feeling of perspective. Compare distant hills with foreground. I used the No. 20 brush for the near foliage.

Step 2 *I used the five colours shown left, second down, for the sky. A wash of Yellow Ochre and a touch of Crimson was extended from the base upwards with broken areas. Ultramarine was washed down and lightened mixing wet in wet leaving ochre patches. Ultramarine and Venetian Red were painted wet in wet for the cloud, leaving the white patch. I used the same colours to block in the buildings.*

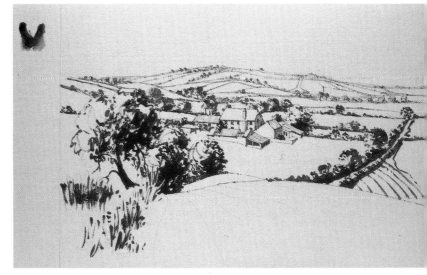

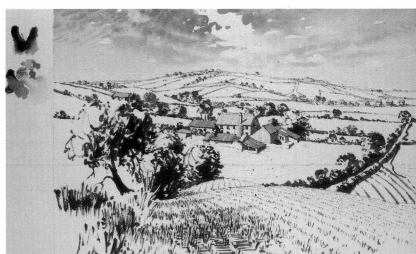

52

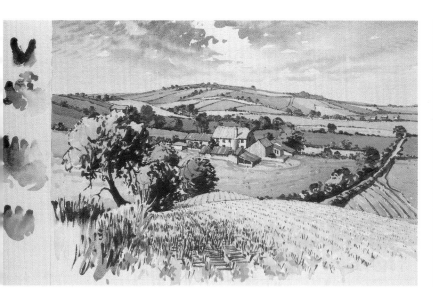

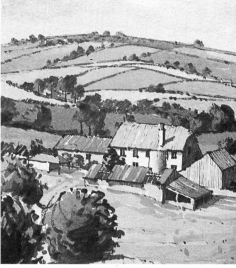

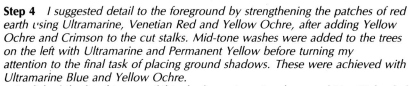

Step 3 *I then set about producing washes over the landscape, working from the distance to foreground (the tonal extremes having been set). The colours used are shown left, third down: Ultramarine Blue, Raw Sienna, Yellow Ochre, and Permanent Yellow. Venetian Red, Crimson and Yellow Ochre were used for the red fields, with Ultramarine added for shaded areas. The mixes changed from a blue bias on the far distant hills, to various greens using the three yellows and Ultramarine in different combinations and strengths. They are all subtly different. I added the cloud shadow behind the farm with a wash of Ultramarine and Yellow Ochre.*

Step 4 *I suggested detail to the foreground by strengthening the patches of red earth using Ultramarine, Venetian Red and Yellow Ochre, after adding Yellow Ochre and Crimson to the cut stalks. Mid-tone washes were added to the trees on the left with Ultramarine and Permanent Yellow before turning my attention to the final task of placing ground shadows. These were achieved with Ultramarine Blue and Yellow Ochre.*

I relished the brushing on of this shadow mix, using the round No. 20 loaded with paint, along and through the near hedge and across the stubble. These shadows bring the painting to life, and complete the composition.

Enlarged Detail *This detail shows the expressive brush line-work to the farm buildings, for example the broken line where light falls, and the thicker line to the shaded areas. The trees are quite loosely drawn and the washes are simple and clean.*

Summary

■ Use expressive line in your drawing: a broken line where light falls; stronger thicker lines on the shaded side of objects.
■ Indicate perspective through change in the width of line, and bold to delicate handling of brush.
■ Tonal extremes should be registered in your drawing, which will therefore have done much to capture the form and character of your subject.
■ Augment and establish the mood by applying straightforward, simple and clean washes with a large, loaded brush.
■ Remember to keep brushes clean and replenish the pot with clean water for wash work.

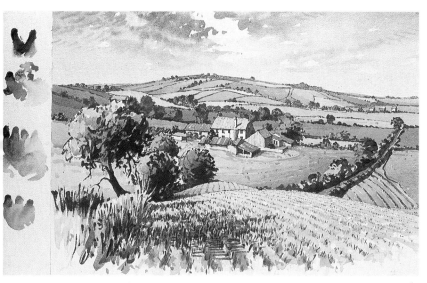

Hard Edge

Hard-edge painting is an extension of the stencilling technique where an image is obtained by pressing a cut-out design (stencil) on to the support, then brushing or spraying paint over it before removing it to reveal the image.

Do-it-yourself car-maintenance enthusiasts have, for a long time, been using the technique to respray or brush paint their car. Masking tape (available at all DIY motor shops) is used to secure newspapers to blank off areas

Full-size reproduction of canvas board, coated with Burnt Sienna wash ground, as used for the example opposite.

not to be painted, and also to form the coachwork lines prior to painting.

Method

A stencil can be used during the execution of a hard-edge painting, for the principle of application is basic-

Floating Planes – Step-by-Step (1–3)

Step 1 *Titanium White was painted up to and over the tape. When dry, the tape was removed carefully as shown to reveal a crisp hard-edged meeting between support and paint.*

Step 2 *Tape was pressed down to form the two shapes (just like a stencil) and Monestial Blue and the orange mix (Permanent Yellow plus Cadmium Red) applied. Tape was removed when the paint was dry.*

Step 3 *The coloured stripes were achieved in the same manner. A master drawing was produced beforehand, and each stage traced through to locate the lines for positioning the tape.*

ally the same. Masking tape is firmly applied to the support, making sure that the edges are firmly attached to prevent paint seepage. The intention is to produce a sharp clean line, so any blemish at this point will spoil the knife-edge image. Acrylic paint is then applied up to and over the tape. When the coating is dry the tape is carefully pulled away to reveal a sharp clean edge.

Application

The technique can be used to create whole paintings which could be figurative in concept, imaginative or totally abstract. Hard edge could also be used in conjunction with other freer techniques as a point of emphasis, or contrast. As with other techniques using acrylics, there would appear to be no limits to its use.

Paint and Brushes

Flow Formula acrylic paint's fluid formulation enables it to produce flat even areas of colour, which make it ideal for producing good crisp hard-edge painting. Glazes can be produced using glaze medium, or water tension breaker if you wish the layer to be brush-stroke free. Use synthetic flat brushes.

Summary

■ Press masking tape firmly on to support. Paint up to and over the tape. Wait until dry and remove carefully.
■ Quick drying power of acrylic paint permits swift follow on of applications.
■ Both opaque and glaze coats can be applied in this way.

Example: Inside, Outside

This painting was inspired by the District Centre that I designed for Wonford, Exeter, whilst with the Architects Department in the Department of Planning and Property, Exeter City Council. The painting symbolizes the confluence of the three main elements, which included a community hall, a youth club, a field changing pavilion, a sports centre and nearby housing. These elements were designed to be built in phases, and in such a way that, individually or collectively, they would be aesthetically pleasing, should remaining phases not be built. The client required an entrance that was both airy and cheerful (see below). I used opaque and glazed applications.

Pitt Farm in Hard Edge – Step-by-Step (1–4)

The hard-edge technique is usually associated with abstract painting executed in the manner illustrated on the previous pages. My decision to include a comparative analysis in the presentation of the various techniques dictated that the method be used in a figurative or representational idiom.

INTERPRETATION

You will see, when you come to the section in which I explain my own studio technique, that the approach here is similar, if somewhat simplified and less ethereal. The various elements have been taken, shaped geometrically and arranged so as to emphasize the point of interest, the farm.

SUPPORT AND PREPARATORY WORK

I used prepared hardboard (smooth face) for the support. Any surface that will happily take mastic tape will suffice. Canvas is excellent but more expensive. I applied two coats of acrylic gesso primer and then, when dry, one wash of Burnt Sienna to provide a warm ground.

I made a master drawing on detail paper, following a few sketch arrangements. Charcoal was rubbed on the reverse side, smoothed with my fingers to remove any excess particles. I then placed the sheet over the support and drew over the design with a hard pencil to complete the transfer.

Step 1 *The tracing, in a very light application of charcoal dust was sufficient to provide a precise guide for the placing of the mastic tape.*

The procedure was the same as I used for the more figurative renderings of the subject. I started on the sky first, setting down the main angles of the composition, and linking with, and at the same time registering, the darkest darks of the foreground trees. The cob wall of the farmhouse, the lightest light, was also fixed. You may have noticed that some areas of colour are flat, but most are graded. This is done to achieve pictorial perspective, suggest form and depict light and shade.

Step 2 *I continued to work on the sky using the colours shown top left. Ultramarine Blue, Venetian Red and Titanium White were mixed for the cloud areas. The darker shades were applied first and the light mix blended in, wet in wet. I added gel retarder to mixes when producing these very fine smooth blends, because the process takes longer. The trees and farm buildings were tackled in the same way, removing the tape from adjacent areas as I proceeded.*

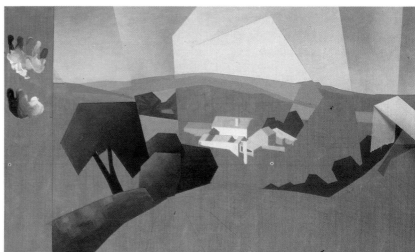

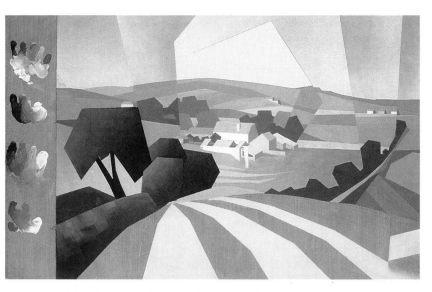

Enlarged Detail *This detail of the tree in the foreground shows the crisp clean lines that are produced when the tape has been removed. Note also the tonal grading to suggest direction of light, and form.*

Step 3 *I added the far- and middle-distance fields with mixes using Ultramarine Blue, Yellow Ochre, Permanent Yellow and Titanium White (left, third down). For the red fields, I mixed Venetian Red, Crimson, Yellow Ochre and White in varying proportions. I worked within the segments formed with the tape and, producing graded tones within the tonal extremities fixed in step 1, I was able to suggest distance.*

I then turned my attention to the foreground field and, again, using the masking tape, I introduced the accentuated perspective of the crop markings. I used a graded mix of Yellow Ochre, Permanent Yellow, Crimson and White. Note the tape being removed from the third stripe.

Step 4 *Using the same colours, but with a darker mix, I completed the foreground field, adding the red earth, Venetian Red, Crimson, Yellow Ochre and White. Masking with the tape throughout, I applied the lighter tones to hedges and trees.*

The source of light now indicated, the sunlight is further emphasized by the shadows. These are applied as a glaze so that the colours beneath glow through. I added water tension breaker to the thinner mix. An opaque shadow would have been too solid, and the weight is kept where I wanted it, in the foreground tree and hedge.

Summary

- Hard-edge painting does not necessarily refer to abstract art. The technique can be used in a representational way as shown above.
- Produce a master drawing first, and then transfer to the support.
- The tape has to be applied in a precise manner, and the preparatory drawing will provide a guide.
- If you use Standard acrylic paint, thin slightly and add water tension breaker. Thin the mix still further for glazing.
- Add water tension breaker to Flow Formula when glazing.
- Add gel retarder if you intend to produce a finely graded blend, as it takes longer.
- Use the technique for imaginative, representational and abstract work.
- Try combining with other techniques.

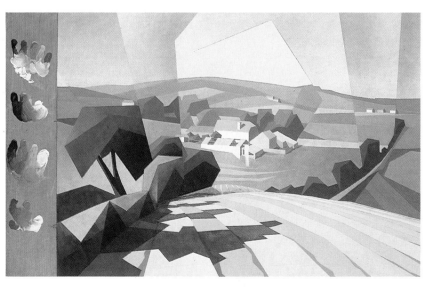

Detailed Technique

The smooth consistency of acrylic paint makes it ideal for fine detailed work. The medium's ability to dry evenly and without any of the sinking that one experiences with oil paint means that there are not tonal or colour changes. Where fine and delicate work is concerned, and particularly when combined with heavier but related impasto work, this is very important.

The capacity of acrylic to be thinned right down to any degree of transparency with water, using a little medium, whilst managing to retain a high-quality presence of colour, makes it eminently suitable for detailed subtle effects.

Provided brushes are washed frequently it is possible to maintain a fine point to deliver the paint.

The medium is a worthy rival of gouache in the field of graphic art and illustration work, where the requisite effects tend to be of a detailed nature. The paint can be thinned right down and used with an air brush, a method which is used a lot in a field of commercial art, to produce finely detailed, lifelike, figurative work.

Artists like David Hockney and Tom Phillips have used acrylics in a figurative detailed manner, the latter combining hieroglyphics in his designs as a form of commentary. The medium's ability to produce fine line-work of the type associated with the detailed rendering of plumage and fur has resulted in an increased usage by wildlife artists.

Topographical work and architectural illustration, where subjects are usually required to be accurately represented, are often executed using this medium. Acrylic is excellent for detailed small-scale renderings of much larger works – for example, murals, where despite the size of presentation it is necessary to show clear, precise detail for approval.

Full-size reproduction of canvas board, coated with Burnt Sienna wash ground, as used for Small Study.

Summary

- Detailed technique refers to the application of paint with a fine brush to produce intricate work. The painting could be figurative in graphic, illustrative, or topographical form, or indeed abstract.
- For the finest delicate work, round sable brushes are the best.
- In general, larger brushes, flats and filberts are used to lay underpainting before building up using smaller brushes, and then applying detail using round.
- One could say that the technique is completely the opposite to loose brush. Although less painterly, the technique is a good discipline which encourages artists to observe and record detail. It will also provide a springboard from which a leap can be made in to freer forms of expression.
- If you learn to cope with detail and understand it, the step to a more expressive painterly approach will be that much easier, for you will instinctively know what to leave out.

Detailed Technique

White Cottage – Step-by-Step (1–3)

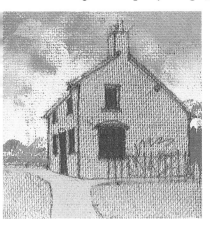 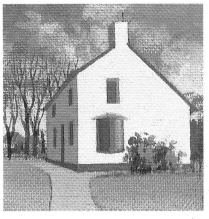 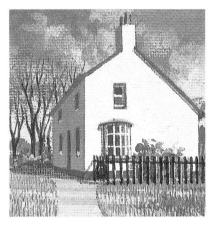

Step 1 *This study was drawn with a No. 3 brush using Ultramarine Blue and Burnt Sienna mix, before the sky and distant trees were blocked in with the bristle long flat No. 8 and filbert No. 4.*

Step 2 *White render, openings, shade, grass and paths were blocked in before the trees were added using a round No. 4 brush for the trunks and branches. A long flat No. 8 was used for foliage, and a filbert No. 4 for the shrub.*

Step 3 *Details were then added using the round brushes Nos 3 and 4, producing fenestration to windows, positioning sills, oriel window, railings, grass and leaves, and finally shadows. The study is reproduced to full size.*

Example: Cartoon Design For Mural, Exeter High Street

Completed in 1980, this is the design I produced for the final stage of an open competition which was organized and judged by The Exeter City Council, Arts Council, South West Arts, and the owners of the building, The Burton Group. The design was a joint winner but for various reasons the scheme, unfortunately, was not proceeded with.

The theme celebrated the 1900th anniversary of the establishment of Civic Administration in Exeter (80AD). Indeed, Exeter was the first City in England to receive a Civic Seal (1170). The design resulted from a lot of research and is quite detailed in content. The wall faces a pedestrian thoroughfare with seating for people to contemplate it! The mural size is over 8 × 11m (26 × 36ft). The cartoon canvas is 980 × 1,200mm (38 × 47in) so most of the painting at this scale is very detailed. The mural would also have been executed in Standard Formula acrylic paint using impasto, flat opaque, and glazing techniques.

Detailed Technique

MATERIALS
For Step-by-Step

- Canvas board with Burnt Sienna wash ground.
- Easel.
- Brushes: Hog bristle long flat Nos 8 and 4; short flat No. 4; filberts Nos 8, 4 and 1; sable round Nos 4 and 1; or use comparative synthetic brushes.
- Cloth.
- Water for washing brushes.
- Two pots of water for mixing.
- Matt medium.
- Acrylic paint (Standard Formula): Ultramarine Blue, Venetian Red, Crimson, Cadmium Red, Raw Sienna, Yellow Ochre, Permanent Yellow, Titanium White.

Summary

- The colour and tonal rendering of the painting is similar to the demonstration in loose brush. I therefore described in more detail which brushes were used for each particular task.
- Even with a detailed representation, the procedure of laying base coats, or underlays using large brushes, should be followed. These preliminary applications can be used to build up form and, more importantly, to establish the tonal range of the painting. Once this has been achieved, detail can be registered using medium brushes and then finalized with small rounds.
- Do not attempt the whole painting with a small brush, believing this is how fine detail is to be achieved – the results are often overworked and lifeless.

Pitt Farm in Detailed Technique – Step-by-Step (1–4)

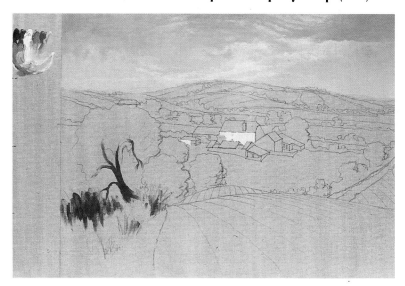

Step 1 *Whatever the technique, the procedure is usually the same. You can see at a glance that I have completed the sky, registered the darkest dark and lightest light. Thus the provider of light, and the resultant tonal extremes, have been recorded, in other words, the parameters of the painting have been set.*

The colours used are shown top left. I first applied Ultramarine Blue and White to the upper sky and added Permanent Yellow to the mix as I worked down to the horizon, leaving areas where cloud existed, and lightening with White as I did so. Then, with a mix of Ultramarine, Venetian Red and White, I added the shaded clouds. Yellow Ochre, Crimson and White were used for the lighter areas.

Step 2 *The distant fields were then painted, those in the far distance being quite blue. I used the two mixes shown second down, for the greens and yellows, and third down for the red fields. The hedges and middle-distance trees were added using the mix indicated fourth down. The tones are darker and colours less blue the nearer the elements are to the foreground. No. 8 brushes were used for blocking and then No. 4 for the trees and No. 1 for the hedges. The farm is blocked in before some detail, such as the distant cottages, is added with the round No. 1.*

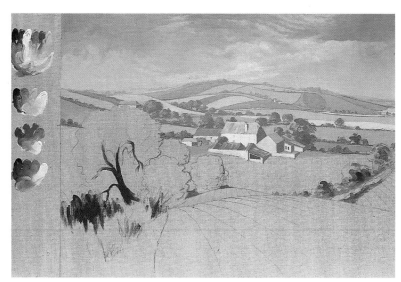

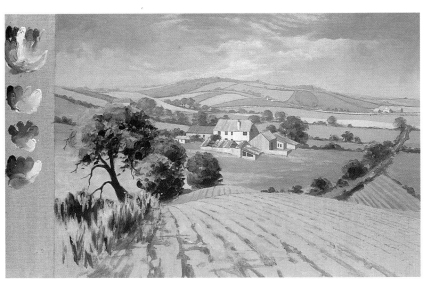

Practice

If, through observation and practice, you can learn to record subjects accurately, and in detail, it will provide a firm basis for developing your own expression and style.

Take your sketchbook wherever you go, record details and make notes. Build up your own visual memory bank which can be used for later studio work: an old and well-tried method, for which there really is no substitute.

Step 3 *Moving out of the painting (towards me), I blocked in the field below the farm and to the right, also the middle and foreground fields, using the flat and filbert brushes No. 8. Perspective was registered with the lines of bare earth, Venetian Red, Crimson, Yellow Ochre and White.*

I then worked on the trees and hedge to the left, painting the dark and mid-tones, Ultramarine, Raw Sienna and Yellow Ochre, providing a basis for more detailed attention.

I returned to the farm, this time with rounds Nos 4 and 1 to record detail, such as window fenestration, piers, corrugations and old purlins.

Step 4 *Detail was now applied to the preparatory layers. Further light tones were added to the middle-distance and far distant trees, being careful to select the correct tints and tonal values, in order to maintain pictorial perspective.*

Detail was added to the foliage of the foreground trees, first using the filbert No. 4 and then the No. 1. Grasses were painted along the hedge and stubble in the field with rounds Nos 4 and 1.

Ground shadows were painted to the farm with the round No. 4, and then to the foreground using the filbert No. 8. Final detail and highlights were then painted using the round No. 4.

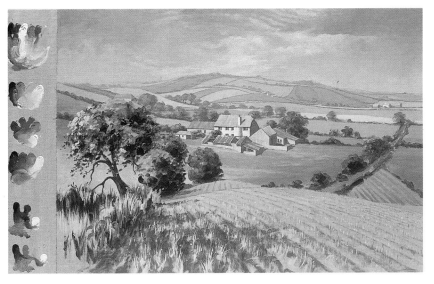

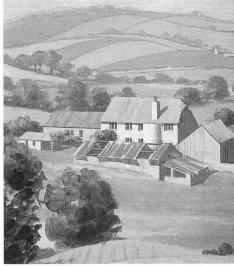

Enlarged Detail *Compare the treatment of the farm buildings here with the lively expressive brushwork in line and wash. The structure was drawn very carefully to begin with and then planes blocked in to provide a base for the detail. The planes in shade were indicated, and then detail was added to define the texture of the corrugated sheeting both new and rusty, together with other items.*

The larger brush marks of the underpaint following the surface form can be seen and these, when combined with the later finer brushwork, contribute to the final detailed rendering.

Collage

If you have opened the book at this section you might be forgiven for wondering how on earth a paint could contribute substantially towards collage work. If, as indeed I hope, you have been reading through from the beginning, you will be fully conversant with the adhesive powers of acrylic paint. The medium not only produces colour, but acts as an adhesive in one application.

Mediums

The matt and gloss mediums are adhesive too and can be used to secure light objects. They are ideal for sticking coloured tissues and papers to the support. Both are suitable for protecting the collage when completed. Glaze medium is also an excellent adhesive, owing to its thixotropic nature.

Texture paste is probably the most useful of all the acrylic mediums in respect of collage. It is a very strong glue which will hold quite heavy objects in place, such as lumps of wood, metal, plastic and glass. The material itself can be moulded in to shapes and sculpted in semi-relief. It can be carved and sanded when dry. The paste can be mixed with paint

Full-size reproduction of hardboard, smooth face, primed with two coats of acrylic gesso, as used for the Example shown opposite.

before application, or painted over when dry.

Materials

Almost anything can be used for collage, except perishable items, such as plants and fruit that have not been dried. Avoid materials that will fade badly.

You can use nuts, nut shells, seeds, seed pods, rice, lentils, all types of pulses dried leaves and flowers, pasta, barley, string, wool, twigs, tin foil, plastic, glass, metal, cardboard, coloured tissues and paper, cork, wood, sawdust, sand, shells, sequins, buttons, beads, textiles; in fact anything that will not perish and can be adhered to the support.

Protection

An acrylic resin-based varnish, or medium in either matt or gloss finish, will help to protect the completed collage. It is even better to place it under glass in a box frame, or a perspex box if the work is in high relief.

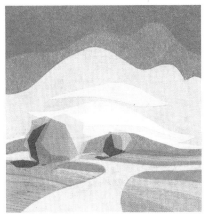

Study (1) *A composition combining the texture of the wood, enhanced by the paint, nuts, pasta and seeds of different shapes diminishing in size towards the periphery.*

Study (2) *Collage gradually built up in layers from the subtly textured wood base, to produce a low-relief L-shaped composition with a message.*

Study (3) *A landscape composition, again using the ply support as a base. White and coloured tissues are cut to shape and then superimposed to blend the colours. I used acrylic matt medium as an adhesive.*

Example: Primary Mix

This is really just a bit of fun to illustrate how acrylics can be combined with materials to produce a high-relief collage. The design was worked out on layout paper and the outline drawing transferred to the support. The square and rectangular elements were made up in thick card and glued with texture paste. The vertical element was made from canvas-board offcuts similarly glued. These were painted white outside and blue-grey inside, and then glued in position again using texture paste. The card drum was similarly added in segments.

The area to the right and left of the drum was built up in texture paste and shaped with the short-trowel painting knife. I then set to work with the paintbrush. Some of the paint chips were formed in relief using texture paste. Finally the wooden dowel members were added, then the string placed, stretched, pinned and then glued. Beads were fixed with texture paste and the features painted blue-grey (Ultramarine Blue, Venetian Red plus White).

Summary

■ Acrylic paint and mediums are ideal for collage. They provide colour and adhesive for both light, semi-relief, and heavier, high-relief work.

■ Paint, matt, gloss and glaze mediums can be used as adhesives for low relief.

■ Texture paste is an excellent adhesive for heavier objects. It can also be modelled, carved and sanded.

■ Almost any material can be used, but avoid perishable items. Collage can be varnished for protection. A better solution is to frame under glass or cover with a perspex box, according to the depth of the relief.

■ Collage can be worked in low profile, for example, as a painting by Bracque or with a bias towards craft as in Study 1, or modelling as above. Your options are, again, very wide.

MATERIALS
For Step-by-Step

- Plywood, primed with two coats of acrylic gesso primer, followed by an application of Burnt Sienna wash ground.
- Easel.
- Brush: Synthetic flat No. 8.
- Surgical blade.
- Acrylic matt medium, used as an adhesive and applied afterwards as a varnish.
- Acrylic paint (Standard Formula): Ultramarine Blue, Burnt Sienna and Titanium White.
- High-quality tissue paper: from top to bottom (*see* step 3), white, black, dark blue, light blue, green, light green, yellow, light brown, red and pink.

Pitt Farm in Collage – Step-by-Step (1–4)

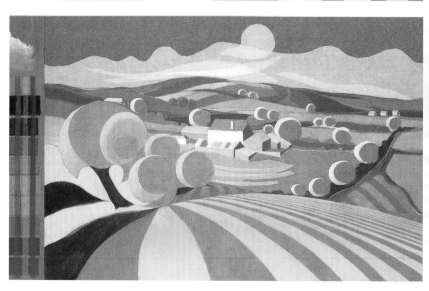

Step 1 *I prepared a design based on the master drawing and transferred it to the support. This provided a base or template against which I could trace the shapes on to the paper before cutting with the surgical blade.*

The white tissue paper was very weak against the ground (see foreground tree where four layers were applied) and I decided to register the lightest light (the farmhouse wall) with Titanium White. I then located the position of the darkest darks with Ultramarine Blue and Burnt Sienna, before placing layers of white and then light blue over the sky.

Step 2 *I continued to apply Titanium White to describe the tonal perspective and provide a light base where appropriate for the papers.*

Step 3 *I applied a layer of papers (see palette to the left), cutting to shape as I progressed, and using light green, yellow, light brown and pink to represent the various crops and state of the fields. I returned to the distance and began overlaying with light blue, thus blending colours and achieving a sense of distance and cloud shadow. I applied light green and then dark green over the yellow paper covering the field below the farm.*

64

Step 4 *It is best when blending colours with papers in this way to lay light colours first then the darks, followed by mid-tones. This procedure will prevent unnecessary obliteration of colour. I continued the blending in this manner, adding hedges and registering the cloud shadows behind the farm. I applied shaded areas to the farm buildings and reds to the corrugated sheeting, adding the dark and mid-tones to the foreground trees. The stripes in the near field were completed, and then finally I added the shadows using light and dark blue, with black along the base of the hedge on the left.*

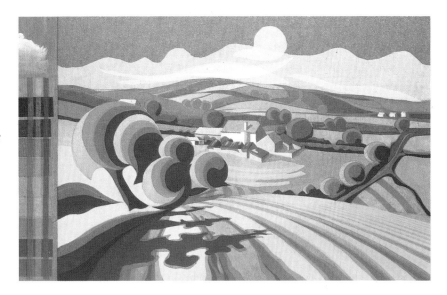

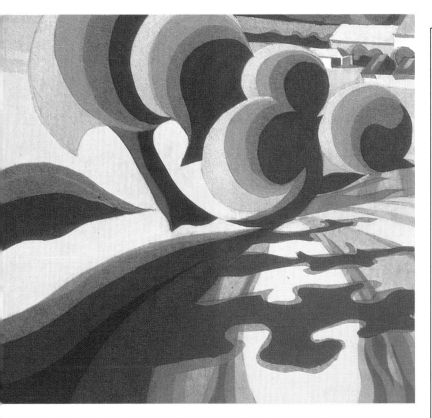

Enlarged Detail *This close-up of the trees on the left of the collage shows more clearly the almost glazed effect that can be achieved by laying one colour paper over another. Titanium White base first, then the light-green paper, followed by dark blue and finally the green. The rather stylized shape runs through the whole design and is echoed in the sky.*

Even more subtle effects can be obtained by overlaying coloured gauze or fine net, and using more colours as there is less likelihood of the colours being obliterated.

Summary

- If you use a tinted ground, as in this demonstration, the base for light tones can be laid with white paint or thicker paper.
- Use matt medium as an adhesive, and to varnish the collage upon completion.
- It is useful to follow the general principle of registering the position of the lightest light and darkest dark at an early stage. The precise values can be adjusted if necessary by adding paper (the full tonal range was not achieved in the demonstration until the black was applied at the end of the final stage).
- Aim for a clear consistent design approach.
- Remember to apply light tones first, then dark followed by mid-tones.
- Varnished, this collage could be framed unglazed as it is totally flat, that is without relief. Glass would, however, afford better protection.

Sponge

Sponge techniques are sometimes used for large-scale abstract work which use copious amounts of paint. Huge canvases can be covered with great swishing sweeps of the arm, controlling the amount of paint released by adjusting the squeeze on the sponge. Smaller works can be painted using smaller sponges of various textures, to create abstract and figurative paintings. I shall deal with the latter as applied to landscape painting, and when you have tried the technique you will be able to experiment and try all manner of applications and, it is hoped, develop your own.

Sponges

There are various types of sponge available. The natural sponges tend to be expensive, and I have used synthetic material for the illustrations reproduced here.

For detail work, an old dense foam cushion will suit very well. A piece cut square at one end and with a chisel shape at the other (type A) will perform many strokes as shown opposite. A medium sponge with the corners rounded off (type B) is useful for general rounded work, for clouds and stippling. I first saw this done by my parents just after the war when I was eight, when stippling with distemper was the economic substitute for wallpaper. A sponge square cut and rounded at one end with one edge roughened (type C) is excellent for hedges, trees and foliage. A simple square-cut sponge (type D) is also useful and can be adapted for all uses according to how you hold it.

Method

Mix the paint on the palette with the sponge squeezed so as not to take up paint. Adjust the take-up of paint by the amount of squeeze, and apply to the support. The amount delivered is controlled by pressure of the sponge and the amount of squeeze.

Full-size reproduction of canvas board, with a Burnt Sienna wash ground, as used for the Example opposite.

Summary

- The sponge technique enables the artist to cover large areas of the support very quickly. Different shapes can be prepared for specific functions, for example broad underlay, and more detailed applications.
- Remember to squeeze the sponge when mixing, otherwise it will take up too much paint.
- Paint is delivered, not only by simply applying the sponge to the support, but by varying the pressure against the surface, whilst controlling the release of the paint by the amount of squeeze.
- Keep the sponges well washed to prevent them clogging. It is best to be near a sink for this purpose, or have a bucket of water handy.
- Some simple, but marvellous effects can be achieved quickly and effectively to give the illusion of detail. Practise on cardboard to get the feel of the technique, and then try your hand on a canvas board, or better still a canvas where the give will accept your touch even more responsively.

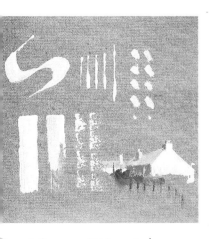

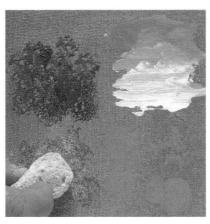

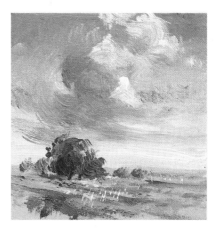

Type A Sponge *Various strokes can be achieved with either square or chisel ends, for example edge, sideways and down in squiggle movement, line with edge, dots with inclined edge, flat and broken movement.*

Type B Sponge *Stipple and blending with stipple. Load sponge and dab gently on support. The sky is blended using the wet-in-wet method. The surface of the sponge produces a lively texture.*

Landscape Using Types A, B, and C *Type B was used for the lively sky; type A for the distant hills, and foreground detail; type C for the trees and field.*

Example: Salisbury Plain

Large tracts of limestone chalk and flint, with curvaceous fields punctuated by dense rounded tree clumps, and sentinels in single file make up a landscape quite different to the red fields of Devon: an ideal spot for a sketch. I always carry a sketchbook with me, a small 160 × 110mm (6 × 4in) size to fit in the pocket, or larger if space permits. I use a soft pencil or conté crayon and often opt for charcoal, which is excellent for rapid work.

The view chosen for this example is typical of the scenery I have described. Most of the painting was painted wet in wet, and I added gel retarder to maintain the fluid consistency for as long as possible. I used the type B sponge for the sky, type D for sweeps across the fields, type C for the trees and foreground, and type A for the buildings, field to the left and highlights.

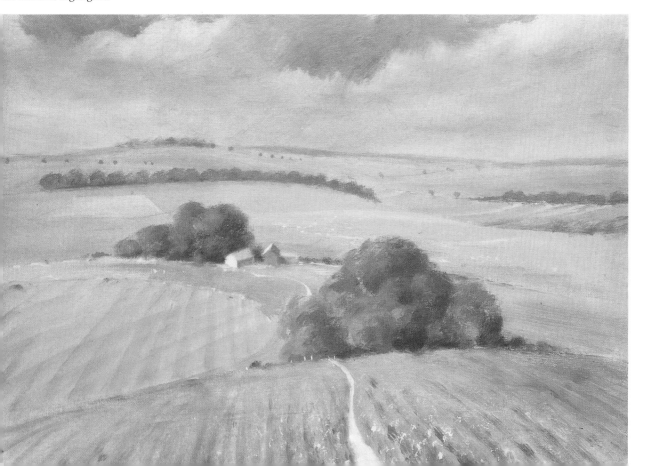

Pitt Farm with Sponge – Step-by-Step (1–4)

MATERIALS For Step-by-Step

- Canvas board, with Burnt Sienna wash ground.
- Easel.
- Sponges: Types A, B, C, and D.
- Gel retarder.
- Acrylic paint (Standard Formula): Ultramarine Blue, Venetian Red, Crimson, Cadmium Red, Yellow Ochre, Permanent Yellow, Titanium White.

With all techniques, and some more than others, expression is achieved through co-ordination between the artist's brain and hand, where the fingers and implement should be considered as one. The pencil, pastel, brush or, as in this instance, the sponge, should become part of your anatomy, an extension with which to dispense your medium. The importance of learning to assess and judge the pressure required to obtain the desired accent when applying the medium to the support cannot be overstressed. It is only through practice, experimentation and experience, that you will be able to control what you are doing. Experience can only be gained through making mistakes and learning how to correct or, better still, avoid them. I do, and will, no doubt, continue to do so, as long as I

Exercise

Try the following strokes with a type B sponge, assess the results and produce some variations of your own.

1. Simple sideways movement with loaded sponge.
2. Same movement, but squeeze and release half-way through stroke.
3. Controlled squeeze and release.
4. Quick squeezes and releases through stroke.
5. Squeeze in one position.
6. Repeat with fairly dry sponge (compare the results with dry brush).

search to improve and develop m work. So don't hold back for fear o making a hash, have a go and enjoy it

Step 1 *I shall not dwell on the procedure for it is the same as before; it is the method that is different. I have used the same colours as before, too (those for the sky are shown top left). I swept the blue mixture across the sky, lightening and introducing Permanent Yellow to provide a greener tint towards the base. I left areas to receive the main parts of the cloud. Some of these remained. Using the same sponge I mixed Ultramarine Blue and Venetian Red for the shaded areas and blended wet in wet, squeezing paint out for the more dense and darker tones. I then added the light tones. Darks to trees and blocking in and lights to farmhouse were registered.*

Step 2 *I laid the base coats over the landscape using the type B sponge working wet in wet. The type D sponge was used for the middle field area. Areas were quickly covered with greens, yellows (second down) and reds (third down) with more Ultramarine Blue added to the mixtures to register far distant hills and cloud shadows.*

The type C sponge was used to indicate the crop markings in the near field. The paint has so far been applied in mid- and light tones, well within the extremes set during the first stage. I started to position the distant cottages using the type A sponge.

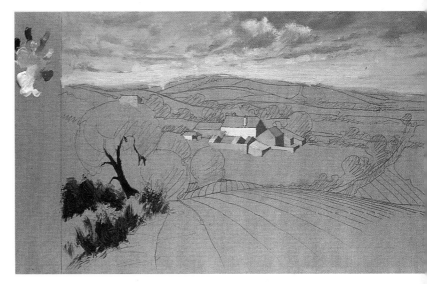

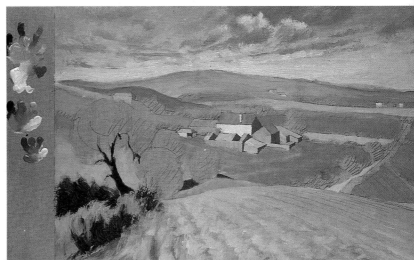

68

Step 3 I returned to the far distance and worked my way back towards my position registering the hedges and trees. Some of the furthest hedgerows were painted with the type A sponge using the chisel edge but most were achieved using the type C sponge. The mix for the trees was basically the same: Ultramarine Blue, Venetian Red, Yellow Ochre and Titanium White. The proportions were varied and in particular the amount of Ultramarine was increased the further away the subject matter. Tonal variation was carefully handled too. The tones become lighter the further away they are from the viewer.

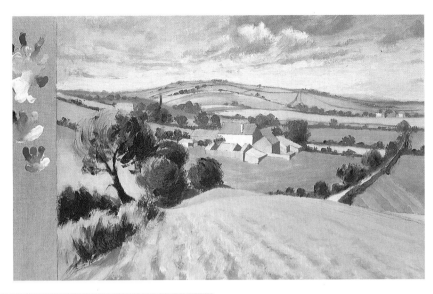

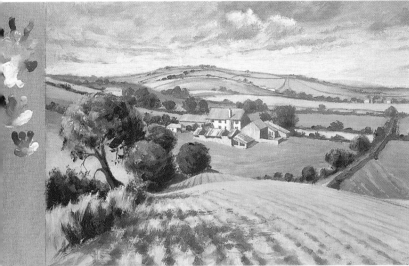

Step 4 A few adjustments were made to the middle field, far left and right, where shadow was added, before I added some detail to the farm buildings. Chimney projection, windows, openings, corrugations and eave shadows were indicated, and the far buildings completed, all with the type A sponge. I used the long chisel edge, and also tilted the sponge to use the corner which provided a point. Then, with the type C sponge, I added light tones to the trees and hedges, firmed up the foreground, and placed shadows, before I applied the highlights with the type A sponge.

Enlarged Detail Note the textures produced by the type A sponge: the building and distant hedges. Type B: the sky and underlay. Type C: the trees and hedges. Type D: the middle field.

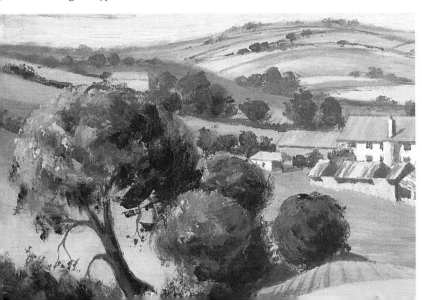

Summary

- Practise and experiment with the sponges first, using any cheap support.
- Use gel retarder to prevent paint from drying too quickly when painting wet in wet.
- Lay the base cover and then apply or suggest detail.
- Flow formula can be used where even applications are required and for base coats. I prefer standard formula for later work as its thicker consistency allows it to 'stand up' better.
- Sponge work can be combined with other techniques, for instance it can be used as a base for brushwork.

69

Painting Knife Technique

The Suitability of Acrylic Paint

The thick, buttery type consistency of Standard Formula acrylic paint makes the medium extremely suitable for palette and painting knife work. The paint retains the stroke produced by the knife, no matter how high or low in relief the mark is made. Impasto work of any thickness can be achieved without the fear that cracking might occur later: the flexibility and adhesive qualities of acrylics ensure that this will never happen.

Mediums

I sometimes use acrylic texture paste when combining painting knife work with other techniques, for example shaped areas can be formed with the knife using the paste and then brush-painted when dry. The knife can be used in this way to build up heavy impasto prior to brushwork. When using the painting knife technique throughout, however, I find it is best to use only the standard formula paint. It is easier to blend on the support. Texture paste can be mixed with paint on the palette but the colours are lighter, and darker, covering coats are more difficult to achieve with a knife than with the brush. If you intend to do a lot of painting knife work, it might pay to persevere with the paste if you are working in deep impasto. Gel retarder could be used to assist with the blending. The answer of course is to experiment.

Used neat, full advantage can be made of the paint's ability to retain its sharp edges. Therefore, the only medium I use is gel retarder to maintain the blending time for as long as possible where required.

Application

The illustrations below show a number of ways in which paint can be applied with the knife. Flat layers can

Full-size reproduction of canvas board with a Burnt Sienna wash ground, as used for the Step-by-Step demonstration overleaf.

be applied over which rich-textured impastos can be developed. Cranked knives were used for the Small Studies and Example. The various shapes are capable of producing a wide range of marks. The straight-bladed palette mixing knife is also useful for spreading level areas of paint.

Summary

■ Standard Formula acrylic paint is ideal for the painting knife technique. The thick buttery consistency retains the marks exceptionally well.
■ Paint of any thickness can be applied.
■ Use a little gel retarder, if you wish, to maintain blending power for as long as possible.
■ Use the flat face, tip and edge of blades to produce a variety of marks. Follow the direction of the contours, surface, form and shape of the subject matter with your strokes, and utilize the properties of the paint to produce lively and expressive texture.

MATERIALS

■ Easel.
■ Gel retarder.
■ Water.
■ Cloth.
■ Painting knives (left to right): Narrow pear shape, medium pear shape, small pear shape, and short trowel. (These are all cranked.)

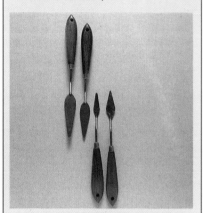

For Small Studies

■ Cotton stretched over card, glued with acrylic paste, and coated first with acrylic gesso primer and then with a Burnt Sienna wash ground.
■ Acrylic paint (Standard Formula): Ultramarine Blue, Cadmium Red, Yellow Ochre, Permanent Yellow, Titanium White.

For Example

■ Canvas board with a Burnt Sienna wash ground.
■ Acrylic paint (Standard Formula): Ultramarine Blue, Burnt Umber, Burnt Sienna, Raw Umber, Venetian Red, Crimson, Yellow Ochre, Titanium White.

Painting Knife Technique

Flat Layer *Ultramarine Blue and Titanium White mix spread evenly like butter, using the narrow pear-shape knife. Used for base coats, or flat skies with some blending.*

Marks *Use the spring-like quality of the blade to form ridges and indentations. The face, side and end of the blade can be made to push and squeeze paint to form texture.*

Planes and Texture *The contours and planes can be accentuated by squeezing out the paint to provide texture in layers. Highlights can be further heightened with texture, for instance, grasses can be added with the edge of the trowel-shaped knife.*

Example: Winter at Posbury, Mid Devon

Posbury Clump is an elevated area, and when it snows the long steep fields provide excellent toboggan and ski runs.

The Ultramarine Blue and Venetian Red mix wash provided an ideal ground as a base to work on. The sky was painted first using flat strokes of the medium pear-shaped knife to apply a blue-grey mix of Ultramarine Blue, Venetian Red and Titanium White. Yellow Ochre and Crimson were added to the mix and blended in towards the lower part of the sky. The darkest darks (trees) were then registered. The colour of the sky was reflected in many tones throughout the landscape, the lighter accents and shadows being thrown from the left by the lowering afternoon sun.

Paint was applied to the distant fields, holding the knife horizontally and combining downward strokes with sideways movements. Hedges were painted by picking up paint from the palette along the edge of the knife and dispensing with the blade edge held along the hedge line and almost at right angles to the support. The trees were laid with both the flat face and

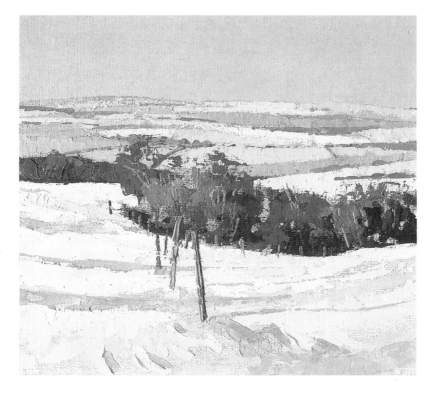

tip of the pear-shaped knife. The foreground field was registered first in sweeps of warm mid-tones, cool blue greys and then warm ochre pinks to sunlit patches. Knife strokes followed the contours and textures in the snow. The trunks, branches and posts were added with the edge of the trowel knife.

MATERIALS
For Step-by-Step

- Canvas board with Burnt Sienna wash ground.
- Easel.
- Painting knives: Narrow pear shape, medium pear shape, small pear shape, and short trowel.
- Brush.
- Gel retarder.
- Water.
- Cloth.
- Acrylic paint (Standard Formula): Ultramarine Blue, Burnt Sienna, Venetian Red, Crimson, Yellow Ochre, Permanent Yellow, Titanium White.

Pitt Farm in Painting Knife Technique – Step-by-Step (1–4)

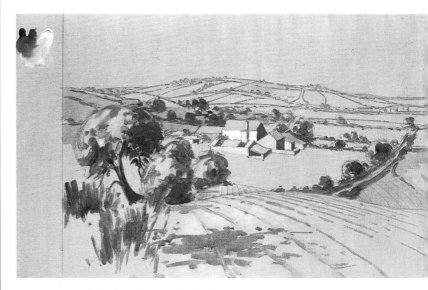

Step 1 *I used the brush to establish the composition and tonal arrangement. This preliminary underlay provides a firm foundation for the painting knife work which will eventually obliterate the brush strokes. Ultramarine Blue, Burnt Sienna, and Titanium White (top left) were used.*

Step 2 *I applied a flat even coat down over the sky, blue at the top and blended and lightened through to a blue green towards the base.*

I worked in a mix of Yellow Ochre, Crimson and Titanium White from the colours shown second down, upwards from the base and registered the light shades of the clouds. Using Ultramarine Blue and Venetian Red I registered the dark shades and, with the end of the pear-shaped trowel, followed the form of the cloud, blending to produce mid-tones.

The distant hills were painted with the small pear-shaped knife in the direction of the contours with a blue-green mix using Ultramarine Blue, Venetian Red, Yellow Ochre and Titanium White.

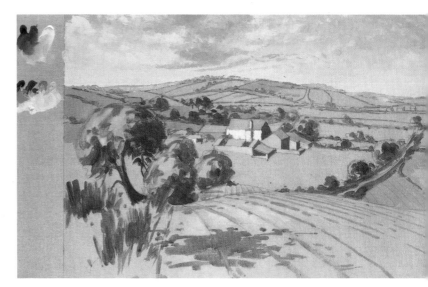

Step 3 *The field pattern is laid applying similar mixes as before, greens, blue-greens, yellow-greens, and reds (third and fourth down). Both pear- and trowel-shaped knives were used, the pear for broader shapes and the trowel edge for the angular and pointed shapes. Hedges were registered with the edge of the small pear-shaped knife, and then using the end of this, and that of the larger pear-shaped knife I painted the distant trees. The round shapes were made by squeezing the paint out from under the end of the knife. I then blocked in the farm buildings and near fields.*

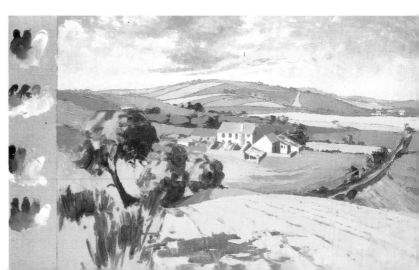

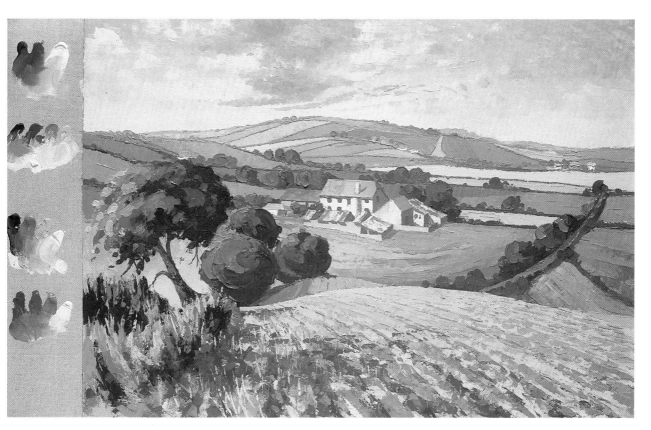

Step 4 *The hedges and trees in the middle-distance and foreground were painted with the medium pear-shaped knife, first applying the dark tones, then medium and finally the light trees. The paint was squeezed out from the side and end of the blade in movements following the shapes of the trees. The crop lines were placed in the foreground field and shadows positioned before the final highlights were painted, the grasses with the edge of the knife, and foliage with the tip.*

Enlarged Detail *Note the flat strokes in the sky and fields, the strokes made with the knife edge for the distant hedges, the knife end/tip for distant trees, the knife side/end for the near trees, and the flat directional strokes for planes of the farm buildings.*

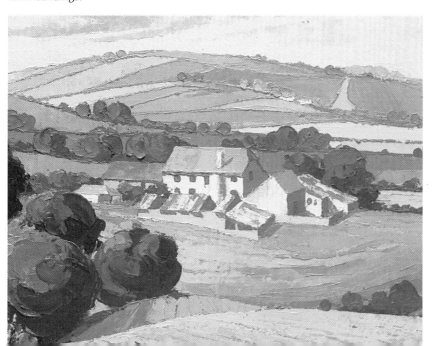

Summary

■ Produce underpainting with thin mix, to establish composition and tonal range.

■ Lay flat coat first and then build up paint where impasto is required, using the appropriate knife, and follow the shape and contours with the strokes to produce a lively texture.

■ The texture produced by the painting knife imparts life to a painting in a similar way to that achieved with the brush in loose brush, provided the marks relate to form.

My Own Studio Technique

MATERIALS

- Easel.
- Glaze medium.
- Gel retarder.
- Cloth.
- Water.
- Brushes – Generally used for flat opaque areas and glazing (left to right): Hog bristle long flat No. 8, short flat No. 8, synthetic flat No. 14.

For Step-by-Step

- Hessian, glued to hardboard with acrylic paste and left natural colour, sealed with matt medium.
- Brushes: *See* above. Also flat No. 4, round No. 4.
- Painting knife: Short trowel.
- Texture paste.
- Acrylic paint (Standard Formula): Ultramarine Blue, Burnt Sienna, Venetian Red, Crimson, Yellow Ochre, Titanium White.

For Example

- Hardboard, smooth side, battened on rear; Natural colour, sealed with matt medium.
- Brushes: *See* above. Also, flat Nos 12, 4 and 1, round No. 4.
- Acrylic paint: Ultramarine Blue, Cobalt Blue, Burnt Sienna, Venetian Red, Crimson, Yellow Ochre, Permanent Yellow, Titanium White.

Throughout the book I have expounded the virtues of acrylic paint, encouraging you, I hope, to experiment with different combinations, and perhaps find other ways of applying the medium.

I enjoy the free spontaneous expression to be found when working out of doors, referred to as *en plein air* painting. A lot of my work is produced in this way. I also use the studio to paint in the same loose manner, working from sketches and material gathered from outside.

I am also experimenting with and developing another style, which could be described as being the antithesis of my usual approach. I thought it would make an interesting study to talk you through the technique as it stands. Although I would not recommend you to copy the method, it may encourage you to investigate the possibilities of how you can, in your way, use this fantastic medium to advance your own ideas.

The theory behind my current approach is derived from the way we see things. When we look at an object or certain point in the landscape, it is, if our eyes are working properly, usually in focus. Our mind also focuses on this area of interest and subconsciously we enlarge it. In my work, I paint this image in sharp focus. The foreground particularly, is completely out of focus and the edges are 'ghosted'. These ghosting lines are projected and shaped to accentuate further the centre of interest. Elements within the subject matter are usually simplified to accord with the geometric design.

Method

The painting as shown opposite, is built up in glazes on an opaque base where darks and lights are sometimes applied with a knife using texture paste.

Summary

- Acrylic paint is applied in flat and graded opaque coats, sometimes in impasto, with or without the help of texture paste.
- Luminous effects are produced where glazes are applied over white or light opaque paint. The darkest dark and other tones are finalized with glazes.
- Scumbling and dry-brush techniques are also used, and graded opaque coats are applied using the wet in wet method, assisted by gel retarder.
- Experiment using the different techniques to express art in your own way. See if you can extend the capabilities of the paint and ancillary mediums, to their limit.

Full-size reproduction of hessian, glued to hardboard with acrylic paste and left natural colour, sealed with matt medium.

My Own Studio Technique

Example: Battle of The M5, Sandy Gate, Exeter (1974)

This is not necessarily a protest painting, but an observation of the hurt and distress that progress inevitably brings to some. There is no doubt that the motorway has greatly benefited the south-west, but there are now pressures for the infrastructure and road network to be increased to connect with the Channel Tunnel. If this happens, incisions will be made across the countryside and dwellings lost, to cause more bleeding of the earth. The cottage, the centre of focus in this painting, was demolished shortly after I completed a series of 'works-in-progress' sketches.

The earth-moving machine, bulldozer, dust, exhaust and earth shapes are out of focus and ghosted in a geometrically designed composition to accentuate the point of the interest, the cottage and outbuildings. I used a combination of flat and graded (wet in wet with gel retarder) opaque, dry-brush and glaze techniques.

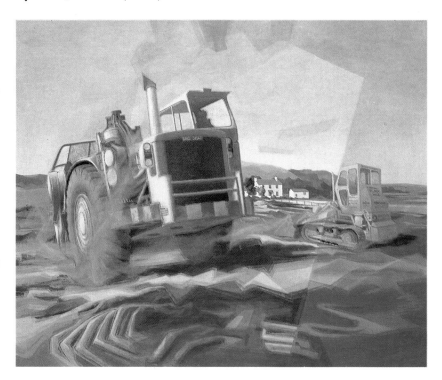

Cornish Tin Mines – Step-by-Step (1–3)

Step 1 *The composition was drawn, and the lightest lights applied to the cottage and sky, and darks to trees. Granite boulders were positioned with texture paste, using the knife.*

Step 2 *Base coats to sky and mines were completed and main projections established, generated from trees and bushes, foreground right. Mines, road and grassed areas were then blocked in.*

Step 3 *Shadows and openings were added to mines. These remain as sharp images, whereas I apply glazes to the foreground over opaque base, and extend ghostings into the sky with more glazes.*

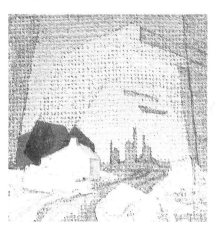
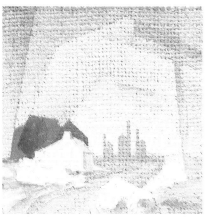
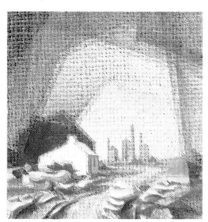

My Own Studio Technique

MATERIALS
For Step-by-Step

- Hessian, glued to hardboard with acrylic paste and left natural colour, sealed with matt medium.
- Brushes: Hog bristle short flat Nos 8 and 4; synthetic flat Nos 14, 8 and 4; sable round No. 4.
- Painting knife: Short trowel.
- Cloth.
- Water for washing brushes.
- Water for mixing.
- Texture paste.
- Gel retarder.
- Acrylic paint (Standard and flow formulas): Ultramarine Blue, Burnt Sienna (Cryla only), Venetian Red, Crimson, Cadmium Red, Raw Sienna, Yellow Ochre, Permanent Yellow, Titanium White. (For large areas where flat and especially graded coats are applied it is an advantage to use Flow Formula, where its slightly longer drying time and more fluid formulation will ease the task.)

The master drawing prepared for all eight demonstrations was produced from a charcoal sketch made on site. This is the procedure that I normally adopt for the studio technique paintings. Making the initial decisions with regard to selection of subject emphasis is best made in situ, and this invariably paves the way for better results. If the technique or lack of time prevents you from painting outside, sketch whenever you can. Your powers of observation will improve to the extent that you will be able to draw upon your mind for inspiration, as well as from your sketchbook.

Pitt Farm in My Own Studio Technique – Step-by-Step (1–4)

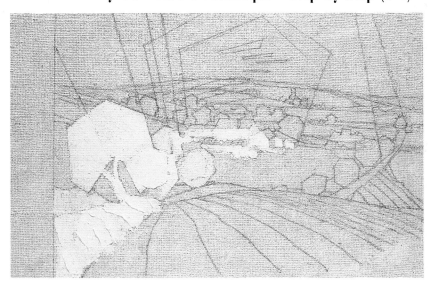

Step 1 *The design was transferred to the support, and the foreground trees, hedge and lighter elements such as the walls of the farm buildings were registered with texture paste. This was applied in relief with the short trowel painting knife.*

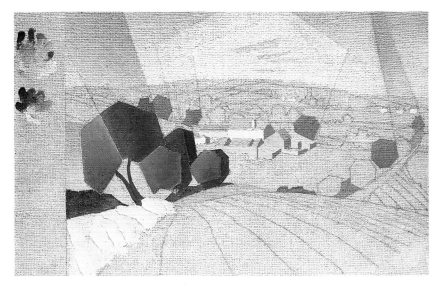

Step 2 *The sky is underpainted in graded opaque colours using the mixes shown top left. Gel retarder was used to extend the drying time to facilitate the subtle blending of the blue down through green blue and further lightened with Titanium White, Yellow Ochre and Crimson towards the base. These last three colours were used for the light patch in the centre. The shaded and graded areas, left and right, were registered using Ultramarine Blue, Venetian Red and Titanium White.*
The trees forming springing points for the projections were blocked in using the mix shown second down. Base coats to the farm buildings were painted with flat layers, identifying the shaded areas.

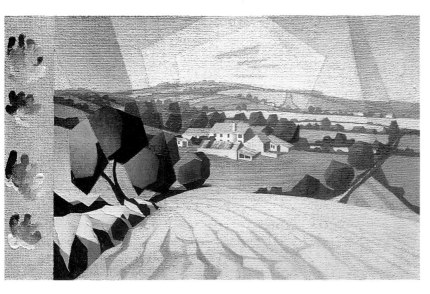

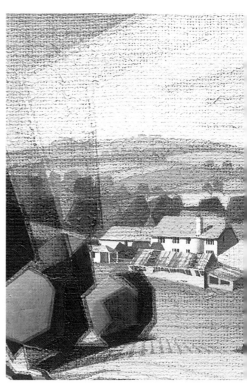

Step 3 I worked from the far distance towards the front laying base colours to fields, hedges and trees. Shapes were simplified to accord with the overall design. The colour mixes used are indicated third and fourth down.

Tonal differences are carefully handled to achieve pictorial perspective. I returned to the hedges and trees adding mid- and light tones. I then added detail to the farm buildings, bringing elements in to sharp focus. Windows, openings and roof corrugations were painted using the sable round No. 4 brush.

The painting is now ready to receive the various glazes, ghosting and tonal adjustments.

Enlarged Detail *Note how the differences in texture (some quite subtle) between the near trees, farther trees, fields, sky and front wall of the farmhouse, heighten still further the accentuation achieved by the ghosting and geometric projections.*

Step 4 Glazes are added to the crop patterns in the foreground field, deepening the red earth (Ultramarine Blue, Venetian Red) and stubble (Yellow Ochre and Crimson).

Shadows were added and then glazes and dry-brush techniques were used to ghost the foreground, the degree diminishing towards the farmhouse. Projections were treated in the same way, the glazing producing a luminous effect over the centre of interest.

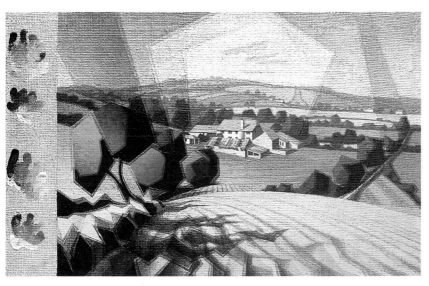

Summary

■ I have included this step-by-step demonstration to illustrate how, by combining a few of the basic techniques once you have mastered them, you can produce something in your own idiom.

■ As I develop the technique, the geometric qualities may increase to almost total abstraction, or move in the direction of my loose work, and become synonymous with it. Who knows? That is the exciting thing about all art: it provides the platform for constant development of expression.

CONCLUSION

My wish is that having read through these pages you will come to share my enthusiasm for this excellent medium. I sincerely hope, if you have not tried acrylics before, you will feel inspired to turn back to the beginning and enjoy working through the exercises and studies, practising and experimenting as you go. If you are a more experienced artist, you might even discover an avenue previously unknown, along which I may have been able to direct you, at least some of the way.

Potential

I mentioned right at the beginning that you could manage very well with standard formula acrylic paint, plus water. The marvellous qualities of the paint would stand up well, and be capable of great diversity of expression. The numerous supports and mediums available, however, increase the degree of flexibility attainable to even higher levels.

Research

Look around the galleries to see how artists use this medium to express their own style. Study their paintings and analyse their handling of the basic techniques of wet in wet, scumbling, dry brush, impasto, glazing and so on. Look at the work of artists who specialize in hard edge, knife painting, collage and loose brush. There is much to be learned from our peers, so look, observe and apply what you have digested in the development of your own approach and style.

Where To Go From Here

Armed with the basic technical know-how you will be able to tackle your work with a degree of confidence. Your whole attention can be given to the portrayal of the subject whether it is still life, landscape, portraiture, flower painting, seascape, or studies of water, boats, trees and buildings.

A keen sense of observation developed through sketching will help you to assess the form, tone, colour and mood of whatever it is before you. Together with the sound technique attained through practice, this will enable you to achieve works of expressive likeness and creativity.

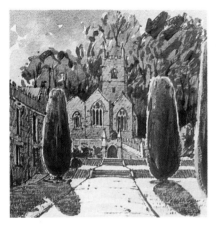

Matt Medium *The medium will provide a unified matt finish, and is particularly useful where a combination of techniques produce matt and eggshell surfaces. Although milky, it dries clear and does not affect the painting.*

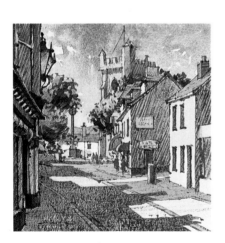

Gloss Medium *This induces an eggshell finish when used as a varnish. It is milky like the matt medium, and also clear when dry. As with the other three varnishes, the colour of the painting is not affected.*

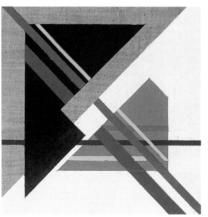

Soluble Matt Varnish *A non-blooming acrylic resin-based varnish, easily removable with white spirit or turpentine. The matt finish will not refract light.*

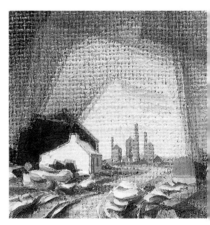

Soluble Gloss Varnish *Similar to soluble matt varnish but, as you would expect, produces a high-gloss finish which can be a nuisance to the viewer.*

78

Sketch and paint on site if you can. If you can not, for whatever reason, there are things to paint all around us, in the home or garden. Try a variety of subjects using the techniques you have learned and practised.

Varnishing

It is not essential to varnish an acrylic painting, but a coating will provide a belt-and-braces protection against the impregnation of grime. The Small Studies, shown again opposite, illustrate the minimal effect varnish has on a painting. The subjects have, since they last appeared in the book, been given a coat, one each of the four finishes available.

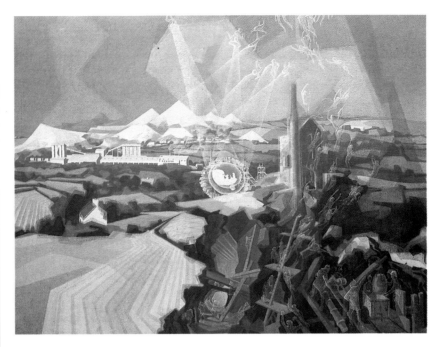

Industrial Resurgence *This painting depicts the demise of Cornish mining and the transcendental rebirth in the expanding china clay industry. Working in parallel suits my disposition at the moment, and although I would not suggest that you acquire two strings to your bow, I do however urge you to use the various techniques and develop them to foster your own particular style.*

Resumé

1. Acrylics were first produced in Mexico in the 1930s.
2. The paint is adhesive, tough, flexible and resistant to oxidizing and chemical decomposition. It is permanent, and not prone to yellowing.
3. Acrylic paint is available in two forms: standard formula and flow formula.
4. Mediums, extenders, texture pastes and retarders combine to provide a system of immense versatility.
5. Use texture paste for impasto, glueing and collage work.
6. Glaze medium is used for glazing, priming and varnishing.
7. Use gel retarder to slow down the quick drying time.
8. Use water tension breaker if you require a completely uniform surface.
9. Use matt or gloss mediums to thin paint, with or without water, and as a varnish.
10. Matt medium can also be used as a primer.
11. Almost any support can be used as long as it is free of emulsion or oil paint.
12. Use inexpensive supports for practice, for example card.
13. Resist the temptation to use too many colours; restrict your palette. You can always try other colours later if you wish to change.
14. Use bristle brushes to express marks in textured work, and sable or synthetic brushes for glazing.
15. Tonal value refers to the degree of lightness and darkness of objects.
16. Aim for tonal harmony, a good balance between light and dark.
17. Register the lightest lights and darkest darks first. The mid-tones will fall between these extremes.
18. Practise the basic techniques of line, impasto, thin, dry brush, scumbling, wet in wet, glazing, and haze and mist.
19. When landscape painting, it helps to deal with the sky first. Then paint your way back to the front laying base coats. Repeat, suggesting more detail and painting from mid- to light tones in each area, working within the overall pictorial perspective (tonal variation to suggest distance).
20. Use the techniques to develop your own style.

STUDIO NOTES

I designed my studio together with a timber-frame specialist who built the frame and outside cladding. I lined and finished the walls, floor and ceiling, fitted out the interior and installed a high level of insulation. The north light is provided by five standard fully glazed doors, top hung and built in as windows. The tables are flush doors mounted on stained softwood frames. Artificial light is provided by daylight flourescent lights, supplemented by spotlights to ensure a good balance of light that is neither too cold nor too warm.

The space duplicates as a small gallery where, with the house included, my wife Anne and I hold exhibitions from time to time. Before the studio was built, and in other houses over the years, spare bedrooms and kitchens have been used.

Water is supplied to the studio from the main supply and the sink is therefore always to hand. When using acrylics you need plenty of water for cleaning out brushes. This is vital if they are to last. If you don't possess a sink, use a bucket.

No matter where you are working, be it studio or kitchen, I wish you every success with acrylics. Good Luck!

First published in 1992 by
The Crowood Press Ltd
Ramsbury, Marlborough
Wiltshire SN8 2HR

British Library Cataloguing in Publication Data

A catalogue record for this book is available from the British Library

ISBN 1 85223 645 0

Dedication
To my wife Anne, and to Russell and Kate, for their encouragement over the years, and for their patience both here and during our travels when the brush has kept them waiting.

Picture credits
All photographs by Sue Atkinson.
The title page illustration is reproduced with the kind permission of Mr and Mrs P. Quartermaine.

Acknowledgements
Thanks to Barbara Rodgers for typing the manuscript and to Daler-Rowney for providing material and technical information.

Typeset by Acūté, Stroud, Gloucestershire.
Printed and bound in Great Britain by BPCC Hazells Ltd
Member of BPCC Ltd